live audio essays

LAWRENCE ABU HAMDAN

natq

Unset pink jelly, teetering between solid and liquid, encases formerly tinned, brine-glossed, mechanically cubed fruit. Uneasily wobbling atop sits a layer of cream, or maybe they are whipped eggs. They taste of the contents of the fridge in which they were stored overnight. Hidden and submerged in this mix are sodden croutons, which would otherwise go unnoticed if they did not cake to the roof of your mouth, slowing the speed at which one needs to quickly swallow each spoonful. Every year, I tell my aunt that it is delicious.

It is not delicious.

Lawrence Abu Hamdan: *So Bassel, what's your book about?*
Bassel Abi Chahine: *My book is about the Progressive Socialist Party, the PLA—the People's Liberation Army. It's a history and a factorial book, and a photography book that shows and expresses the images, and it speaks for itself.*
LAH: *And how long did you take to get all these photographs together?*
BAC: *It took me about ten years. Since 2008, I've been acquiring and collecting these images.*

It was at this same aunt's table, with an unspeakably disgusting dessert awaiting us, where I first met Bassel, the son of my aunt's husband's niece.

We found ourselves sitting across from one another, and being that we are the same age, my aunt sought to break the silence between us. "Lawrence," my aunt said, *"bta3rif inno Bassel Naat2."* ("Lawrence, did you know that Bassel has vocalized?")

Natq is the Arabic word for "vocalization," referring to the physical act of speaking. Amongst our family, as in all Druze households, the word means something quite different. *Natq* is used to refer to a form of speech that is impossible to explain by any means other than reincarnation. The closest translation I can find in English is *xenoglossy*, referring to speech that has not been learned, testimony unknown to the individual under conventionally explainable conditions.

I could translate my aunt's words in simpler terms: "Lawrence, did you know that Bassel is reincarnated?" However, *reincarnation* in Arabic is تقمص, derived from the word قميص, meaning "shirt." To reincarnate, then, literally means "a change of shirt." She did not use that word, as she believes, in continuity with the dogma, that we all reincarnate, we all change our shirts, that every soul transmigrates, but that only a few remember the passage. The more traumatic, unexpected, and violent the death, the more the memories of one's previous life leak into the next. Though all souls return, only those who suffered violent ends speak. *Natq* does not refer to the reincarnation of the soul but the transmigration of speech from the dead to the living.

To be perfectly honest, at that moment of my aunt's exclamation, I did not have any reaction other than to politely feign surprise in the general direction of Bassel. This may be because the last time I heard someone's Natq, it was a distant relative's extremely long and extremely elderly recounting of a story that culminated with the anticlimactic memory of her daughter having had a particular fondness for Chiclets in her previous life.

16

For many of us who grew up in this environment, reincarnation is not in and of itself an exceptional event.

This is not to say that I had never heard a Natq that was alarming and compelling, but before I met Bassel I had never heard a Natq that awoke me to the particular political possibilities of a kind of speech that is conventionally considered impossible.

LAH: *So when were you born, Bassel?*
BAC: *March 27, 1987.*
LAH: *You were born in 1987. And when did Youssef al Jowhary die? You in your previous life.*
BAC: *February 26, 1984.*
LAH: *So when were you, as Youssef al Jowhary, born?*
BAC: *1967.*
LAH: *1967, okay.*

Youssef al Jowhary was fourteen in 1981, when he was transferred from the boy scouts to fight for the militia of the Progressive Socialist Party (PSP), the People's Liberation Army. At the age of seventeen, he was killed by mortar in Bhamdoun, Lebanon, during the peak of the Chouf War.

By virtue of who Bassel was in his past life, he acts as an indictment against the leadership of the PSP, the party for which Youssef fought and died. As the memories of a child soldier are uttered, the memories of war criminals who are still to this day in power, most notably Walid Joumblatt and Akram Chayeb, are inevitably revived. Bassel does not intend to go after these people, though by simply uttering the memories that have transmigrated to

him, and by meeting his family and fellow soldiers from his past life, evidence is revealed substantiating the PSP's use of child soldiers in paramilitary operations, and therefore accusing the leadership of violating international law. Now, though the use of child soldiers is illegal, I do not want to make the assumption that those legally defined as children, under the age of eighteen, had no agency to decide to fight for something they believed in.

Though it is a crime under international law, I believe that human rights do not help us to fully adjudicate on whether the use of children in this context signals a systemic abuse of power. Rather, to understand what or if any abuse of children took place, we would need to know how many child soldiers fought and died, we would need to speak about what roles the children played in their units and to what extent the leadership knew about or had a clear picture of the use of children. To do this, we would need a path to adjudication and investigation which began with those who lost children and with those children who fought and today survive, in order to understand what drove them to fight and who they were.

However, such an investigation and such evidence of the use of child soldiers that Bassel's testimony provokes has no legal forum in which to be discussed or adjudicated today. Their part in the war, whether voluntary or coerced, will remain absent from history. An amnesty was established in Lebanon for all crimes perpetrated before March 28, 1991, precluding any possibility to pursue legal action for crimes committed during the war, and therefore exonerating the leaders of all the factions involved. This obliterated the possibility of creating a

consensus or any verifiable understanding of recent events, or of how we've arrived at where we are now as a nation. It forced truth to be fractured into a thousand pieces. Today each person is armed with their own unverifiable truths. Amnesty did not silence the history of the war; rather, it filled the country with the noise of millions of simultaneous competing histories that create a cloud of misinformation, inherited half-truths.

This is what has allowed these same militia leaders to remain in control of their respective wards nearly thirty years after the official end of the war. They passed a law that initially seemed intended to produce national reconciliation, but has instead solidified sectarian divisions. A law that made the war unspeakable and unteachable. In the name of sectarian protection and the maintenance of peace, these militia leaders have turned municipalities into territories for exploitation, each profiteering from essential services and basic infrastructure as payment for protection from the imminence of the next civil war. This fearsome specter of imminent war creates the condition in which citizens need protecting from each other, hiding the reality that they need protecting from their own so-called leaders and those leaders' harmful and often lethal practices of corruption and cronyism.

This amnesty law means that there is no legal forum in which Bassel's testimony from his past life as a felled child soldier can be adjudicated. However, even if such a forum were to be established, would the logic of crime, as it is currently understood, be applicable to the temporality these lives occupy? For though Youssef al Jowhary was

killed, can we consider a returned person murdered?
Do the returned ever really die? Can the memories of one
person living in the body of another constitute a single
legal person accountable under the law? Can their wrongs
be compensated under the same terms that the law allows
for? And, if they can have no legal recourse, or if the
law is not able to process such claims, then what kind of
justice could the returned seek?

This is a question that is perhaps even more threatening
to those who have used the law as a means to uphold and
protect their autonomy. These aforementioned leaders
made sure the dead could not speak, by, for example,
hiding the location of mass graves. They have used the
amnesty as a legal instrument to ensure the silence of
those who survived the war, and they have made sure
the war is not taught at school to secure the confounding
of future generations. But no one has effectively thought
about those who may return. Reincarnated testimony
poses a very particular threat, precisely because it
operates outside of the law and outside the forms of
witnessing that have been blocked thus far by legal
instruments and political maneuvering.

The threat is further amplified in Bassel's case because
he is not only the return of Youssef al Jowhary, the felled
child soldier who fought in Joumblatt's militia.

His flashbacks to a time in which he did not himself live
have compelled Bassel to become an obsessive autodi-
dactic historian.

A young man pushed to find traces of his own existence, he has used his reincarnation to amass not only information about his own life, but the largest archive of photography, weaponry, uniforms, flags, and badges from the Chouf War and the entire militia of the Progressive Socialist Party.

All the images and objects I will show today are sourced by Bassel. Bassel has now become a historical resource; he holds vital information for anyone hoping to understand the historical record of a time which has been cancelled from history.

Bassel's status as a reincarnated historian is why the leader of the PSP, Walid Joumblatt, schedules regular "catch-up" meetings with Bassel. These are organized with the idea that the PSP will support Bassel's research, support that has thus far failed to materialize. My suspicion is that these meetings, which 99 percent of the time get cancelled last-minute, are an effort to keep Bassel close to the party; to be able to control any narratives that he might uncover. However, in the 1 percent of the time when these meetings actually happen, the queries are not about the use of child soldiers, nor any of the other crimes Joumblatt committed during the war, but about crimes committed against the Druze, the religious sect in whose name this militia fought.

When I learned this, it took me a second: Why would Joumblatt care so much about revealing the crimes done to his sect, over and above the revelation of any crimes he himself committed? While watching an investigative documentary on the corrupt billion-dollar operation

behind the distribution of electricity (or lack thereof),
I finally saw why. Joumblatt is a cosignatory on shadow
companies with Gebran Bassil and Nabih Berri. These
are the leaders of opposing political parties and wartime
enemies. Today they work together to embezzle money
reserved for the purchase of oil for electricity. The reve-
lation of crimes committed against the Druze during the
war could interrupt the crimes Joumblatt is committing
today. Photographs and videos of massacres inflicted
upon the Druze that now sit silently in Bassel's collection
could rile up Joumblatt's base, which would in turn force
him to confront his former enemies, now his business
partners. Though they have successfully convinced their
respective bases that they are opposed to one another,
these "leaders" need the theater of sectarianism but with-
out any of the actual drama.

Bassel's first flashback to his life as the child soldier
Youssef al Jowhary happened at Arlington Cemetery,
the Vietnam War Memorial in Washington, DC. He was
five years old. Perhaps this geographically dislocated
flashback was due to the fact that, despite being Lebanese,
he had never been to Lebanon.

From the day he visited the cemetery, Bassel began
endlessly drawing Arlington.

Yet the more he drew it, the more Arlington started
to transform.

His own name started to appear on the graves, and the
Lebanese flag replaced the star-spangled banner.

Of course, no such memorial as monumental as Arlington exists in Lebanon (except for within Bassel's own child-hood sketchbooks).

Years later, when Bassel was twenty-one, he went searching for Youssef's name on a marble-clad martyrs' memorial in the western part of the town of Aley, not far from where he had died in his previous life, some twenty-four years prior.

Arriving there, he found his name, but the date of his death was wrong. The tombstone read 1989, not 1984. This change of death date covers up the trace of a crime. The year of his death is crucial: Youssef died at age seventeen in 1984. Had he died in 1989, he nor any of the other incorrect dates cataloged here would have been child soldiers.

Finding that neither the official sources of memorialization nor his own memories were adequate or comprehensive, Bassel began to devote more and more of his time to looking for traces of his former existence.

He began collecting martyrs' posters from that period, hoping to find a correct record of his own death and an image of who he used to be.

After collecting and scouring dozens of posters, he had found no trace of Youssef. However, he did unearth, through a family contact, one of the militia's key graphic designers and poster printers. The now-elderly designer gave Bassel free rein amongst his disordered remnants. Amongst the old defective prints, flags, and never-released

designs, he eventually found one in which Youssef's name appeared.

Though here the date of his death was correct, the space where his image would normally appear was left blank. Bassel left the designer's house not only with this poster, but with as many of the half-discarded posters, flags, and badges as he could carry.

Bassel still sought to procure his own image. Up to that point, he had avoided exactly what would lead him to it: his parents from his past life. Inevitably, Bassel knocked on the door of the Jowhary family home in Bhamdoun one day. His former sister opened it. Bassel announced who he was and who he had been, and he was quickly welcomed inside. The elderly man sitting on the balcony, Fouad al Jowhary, Youssef's father, rose to shake his hand. After a discussion prolonged with intermittent bouts of silence, Fouad gave him the uniforms Youssef wore during the war, including the one in which he had died, and the rifle he had used. When Bassel inquired whether there was a photograph he could have, Fouad, his former father, explained that the only existing image they had of Youssef was an out-of-focus black-and-white image, taken when he was five or six years old, adding that Youssef hated having his picture taken.

LAH: *So this is you in the clothes of you in a past life, right?*
BAC: *Yes.*
LAH: *And again, your father in a past life gave you the uniform that you died in or that you were fighting in?*
BAC: *He gave me the clothes of my past life.*

LAH: *And what was it like to get into the costume of you in a previous life? What did it do?*
BAC: *I don't know, scary?*
LAH: *It was scary. In what sense?*
BAC: *You feel like the person is still there.*
LAH: *Right.*
BAC: *Like you're reliving it.*
LAH: *And this image?*
BAC: *This is the only existing picture I have of myself. But I don't know how old I am. According to what they told me, this is six or seven, I'm guessing. Maybe. I'm guessing.*

Thinking that maybe his ex-comrades from the war in Aley might have a picture of Youssef, Bassel began to locate and interview whomsoever he had known. This is how he began accessing and archiving personal photographs and collecting memorabilia from many ex-fighters across Lebanon.

Starting with people who had fought or trained with Youssef, and then the people who had fought and trained with those people, and then people who had fought and trained with those people, and so on and so forth, he created a network across the mountains of ex-fighters and their family members.

Bassel's reincarnation has given him access. His reincarnation and his research are inseparable. If an ordinary, bona fide university historian were to show up at these houses asking for such documents, they would be told that none exist. But as a returned fallen comrade, Bassel is treated differently.

He is, after some explaining, welcomed to see, and then, for the most part, archive this material amongst the community of those who believe in reincarnation.

Bassel is in a unique position to traverse a silence that spans two generations. One is silenced by the necessity and responsibility to avoid stirring up a sectarian past in which they fought, whilst the other, my generation, is silenced by the absence of historical teaching and cognizance of the war.

Bassel feels the confounding historical erasure of a young Lebanese who grew up in the post-amnesty period and, simultaneously, has flashbacks of the war, as lucid as though he were still in its midst. The reincarnated historian straddles a generational divide, and, in some small way, his Natq makes formerly impossible dialogue possible.

LAH: *You got given a lot of personal photographs of people.*
BAC: *Yeah, basically.*
LAH: *How did that come about, how did they give you this?*
BAC: *I would approach people and tell them that I'm working on a project, on making a book, and is it okay if you're willing to help by providing me with photos. First of all, they'd get a bit insecure and tell me, "We don't have photos," and "Why do you need photos?" and they would get a bit alarmed at first. After you open the subject about being reincarnated and who you were, they'd mellow down and then they'd invite you in and they'd show you, and then they'll help you out. Well, it took a lot of work, to be honest. It wasn't easy, that's one thing I can tell you. Most of the people who had these images either burnt them or destroyed them.*

Bassel must keep much of his archive hidden from public view.

For while his interest is in documenting the uniforms they wore, the units from which the militia was composed, the weapons they used, and the locations they trained, paraded, and battled, his archive also contains rare videographic and photographic evidence of war crimes, torture, and massacres, on both sides.

Such images cannot surface under the current conditions in Lebanon, not without the groundwork needed for undoing the sectarian system.

These images, for example, are the first in a series. The images that follow this sequence explicitly reveal war crimes committed by the PSP. I will not be showing you what comes after these images. Not because I feel prudent about the violence they contain, and certainly not because I seek to protect the people who committed these crimes. I will not be showing you these images because it is not Bassel's photographs but Bassel himself that is the evidence here. His work is testament to the conditions that produced and led him to become a witness, a collector, a returned historian. The amnesty, the corruption, the sectarianism—these have created the perfect storm for the production of Bassel as a witness. The political elite have blocked all other pathways to meaningfully speak about the past, and therefore the political elite have unintentionally forged a new path for such stories to emerge. Bassel is the evidence, not of the crimes of war, but of the crimes by which peace was secured. Crimes not from the past, but those being committed today.

This is none the more evident than in Bassel's latest book, titled *Shot Twice*.

Shot Twice is a collection of before and after images in which pictures Bassel has taken of contemporary Lebanon are placed side by side with photographs of those same locations found in the archive he has procured from the ex-fighters.

Throughout the spring and summer of 2019, Bassel made over a hundred before and after images. It was the intensification of a strategy he had been using since 2008 to help him trigger memories of his past life.

Scouring images of places where his former militia, the People's Liberation Army, had been active, he would look for clues, like this one, a sign for Spinneys Centre. This, together with the shape of the building, was easy to locate for someone with memories of wartime and pre-war Beirut. Arriving at the site of the original photograph, Bassel began scanning back and forth between the original image on his iPhone and the building in front of him, until he finally settled his feet as close as he could to where the photographer had once stood. He unfurls his tripod and adjusts the frame through the viewfinder, using the descending angle of the roof to align the two times in which he lived.

This almost perfectly aligned diptych shows a road once occupied by a militia checkpoint that now allows for the free flow of traffic. A leap in time, from war to peace, happens in a single-frame transition. Yet as I scan back and forth, war to peace, peace to war, a detail emerges

that warps this otherwise linear trajectory of progress. They had streetlights in the days of the war, yet today, we have no functioning streetlights on this same strip. Could it be that during the war, infrastructure was better maintained than it is now? Were the taxes unofficially sourced by the militias, armed men knocking door to door, shaking down neighborhoods, actually being reinvested in infrastructure? Now the official taxes we pay to elected officials flow straight into their pockets and up the chain of command, while we are left without electricity or waste disposal, and our roads are full of potholes. I mean, look at these potholes, or how this sign has sadly sagged over time.

Of the little we knew of the war, the one thing that my generation was consistently led to believe was that it was a time of complete chaos and instability. We have been told that the war is behind us, a period we have overcome, but Bassel's before and after images reveal another kind of chronology. And what we will see demonstrated again and again in these before and after images is that although Bassel's historical work speaks of the transmigration of souls, he is not the one telling ghost stories.

In 1986, the People's Liberation Army had joined together with Harakat al Amal to form a military police strike force that controlled West Beirut.

Thirty-three years later, their trace has been more or less erased. This building has been cladded anew, hiding the bullet holes that puncture the surface beneath.

This man and his anti-aircraft artillery are also no longer visible. They too have been subsumed underneath the surface. The wall upon which he sits is the exterior of a building that presently hosts a unit of parliamentary guards. There is a direct line of descent from this joint strike force to the parliamentary guards. The parliamentary guards were formed in '91, when each of Lebanon's warlords institutionalized their former militia fighters into the post-war security and military sector. The parliamentary guards are under the control of the speaker of parliament, who, since 1992, has been Nabih Berri. Nabih Berri, together with Walid Joumblatt, formed the militia for whom this man fought in 1986.

This before and after image does not display the disappearance of the militias from the streets of Beirut, but rather the process of them becoming embedded, sedimented, and swallowed, from the surface to the interior. It is from this interior that they continue to exert sectarian violence. On August 8, 2020, from behind parliamentary walls, peering out from parliamentary windows, these guards fired live rounds at unarmed protesters who gathered outside parliament to demonstrate against the ammonium nitrate massacre.

I have spent many hours on this street because I had a studio for two years in this pink building from the '30s. Though I have never eaten at this restaurant and I have never been inside this strip club, I once, and only once, bought an espresso from a coffee stand that is now located here at the end of the road. Halfway through making my order, I looked around and saw that the place was explicitly adorned with Harakat al Amal images and flags.

On closer inspection it seemed to serve, almost exclusively, armed Harakat al Amal "members." I sheepishly paid and fled, to never return. Though the location where the coffee stand would be erected, years later, is present in this "before" image, in Bassel's "after" image, the coffee stand is conspicuously absent. It is with good reason that Bassel chose not to provocatively point his camera directly at the militia's outpost. It is populated by people who are armed, threatening, and threatened. Documenting them so directly would likely result at the very least in the destruction of Bassel's camera. Though today we feel a fear toward the documentation of these people, it seems that the militia members of the past had a totally different relationship to the camera. As they pass the photographer they pose and throw up V signs. They were acutely aware of their role as the subject of the image. What they did not then know is that one day they too would need to be redacted.

In the flip from before to after, we see a compression of space which forces Bassel's lens much closer to this still-standing Hakim Automotive building. When Bassel takes this photo in 2019, from this spot here, he no longer has the distance nor the vacant space required to restage the image. Building and zoning laws have been in a continually renewed state of exception since they were first implemented, in order to help boost post-war reconstruction. The endless extension of this state of exception has caused rapid densification and the acceleration of urban development on land that was taken during the war, including vast swathes of what was once public space. The control of the land was assumed during the war, but the wealth it generated for the warlords who took the

land all happened post amnesty. Like Bassel, these political leaders are also resurrected from the war, former warlords now reincarnated as policy makers.

Just over a year after Bassel took this image, this SGBL Bank building now looks more like its wartime state than it did in 2019. The August 4 explosion has returned the building to its vacated and windowless state. We move between 1986, through 2019, only to arrive back at 2020.

Either we accept a series of breaks wherein each issue is isolated from the other, each culprit separated by some conveniently ascribed context, or we accept a line of continuation, a collapse of time and events, which Bassel's Natq presents us with. Either these are isolated incidents or the very same crime, in which the very same people who were responsible for the death of a child soldier at seventeen are those who have now stolen the future of almost all the seventeen-year-olds growing up in Lebanon today.

Though Bassel's work pertains to his life in the past, his Natq extends to the theft of the future.

This is one of the least successfully aligned before and after images in the collection. This manhole is the same one we see here. To restage the position where this photographer once stood, one would have to stand in the way of oncoming traffic. Bassel, who lucidly remembers dying once, is unlikely to take such a risk.

Bassel remembers vividly the shrapnel from a mortar attack that lodged in his stomach. In fact, he attributes

many of his digestive problems and intestinal disorders to the same injury that felled Youssef al Jowhary in 1984. This is not uncommon in cases of reincarnation. The Natq of Tali Sowaid, for example, attributes his current speech impediment—an inability to adequately pronounce the arabic letter ش—with his injuries from his past life. Tali Sowaid had a very rare speech impediment; he could not adequately lift his tongue to sound the "sh" of the letter ش. And indeed, the postmortem confirms that Said Abul Hisn, who transmigrated into Tali, died in hospital from complications caused by the bullet, "which entered the left side of his face, shattered his mandibles, cutting the root of the tongue and damaging the lingual vessels and hypoglossal nerve." While Tali was recounting what had happened to him in his past life to Dr. Ian Stevenson, a psychiatrist and professor at the University of Virginia, the doctor noticed that in addition to Tali's speech impediment, he had two birthmarks on both of his cheeks.

This was in 1972, when Dr. Stevenson was in Lebanon conducting research for what would become his life's work: *Reincarnation and Biology: The Etiology of Birthmarks*, published in 1997. The book was the result of fieldwork in Asia, Turkey, Lebanon, across Africa, and Alaska, in which he interviewed individuals and investigated claims of reincarnation, with particular attention to the correspondence of birthmarks on the reincarnated subject to the circumstances of their death in their previous life. Where he could, Stevenson would match the birthmarks on the reincarnated body to the postmortem report of the previous personality. Where the postmortem was inaccessible, he would try to work backward from the birthmark to speculate the mode of death in a previous

life. It is no coincidence that the Stevenson birthmark archive is disproportionately filled with the testimonies of people who exist at the threshold of the law, and for whom injustices and violence have otherwise escaped the historical record due to colonial subjugation, corruption, rural lawlessness, and our old friend, legal amnesty. By establishing an unbroken link between the death wound and the birthmark, Stevenson opens a forum for listening to a network of almost extinct histories. Though his book seeks to posit a biological hypothesis, his lasting contribution is to use the birthmark as an algorithm, aggregating an anthology of erasure.

Though it was a little thicker than it should have been, Dr. Ian Stevenson hypothesized that the mark which encircled Jacinta Agbo's crown resembled the incisions of neurosurgery. This corresponded to testimony that Nsude Agbo, of whom Jacinta was the reincarnation, had died in hospital due to a club wound to the head. Whether or not he was operated upon by a neurosurgeon before he passed will remain unknown. The medical records of Nsude, as well as those of the many who died during the Biafran pogroms, went up in flames when the University Hospital in Enugu was bombarded by the Nigerian military and their British artillery in March 1970. Moreover, as legal amnesty was given to all crimes committed during the Biafran War, very few testimonies of perpetrators have been heard or verified. Jacinta's memories of her past incarnation have faded over the course of her life. Though she visibly carries the marks of the pogroms, she recalls nothing of the event itself, only that she was a man, and that if she had the means, she would return to being a man.

For some misdemeanor, U Tinn Sein's father raised his hand to beat him, but froze in sudden confusion when he heard his son exclaim, "I am going back to Tokyo!" This was the first clear Natq of U Tinn Sein from his past life as a soldier with the Japanese occupying forces stationed in Myanmar. Although in his current incarnation, he had never been to Japan, in his previous life, he had never wanted to leave. His past incarnation was threatened with torture if he did not abruptly end his studies and join the Japanese army to fight in Myanmar. U Tinn Sein does not remember his name, but has lucid flashbacks of a low-flying British or American plane opening fire on his platoon. As he ran for cover, he was shot in the chest. U Tinn Sein did not, however, have a birthmark on his chest where the fatal bullet entered his past incarnation. But on inspection, Stevenson did notice a large birthmark on his lower back. This Stevenson hypothesized to be the position of the bullet's exit wound. The bullet that entered one life, exited another.

Charles Porter was very young when he was taken to an American missionary boarding school in Alaska. In these schools, Tlingit language and culture were brutally discouraged. Despite the punishment he endured, Porter insisted on his past-life memories of being a Tlingit warrior who had died in battle. When he was finally released from the school, he returned to his village and spoke of his memories; his parents took him to see the most elderly woman there. She held a Tlingit battle spear to his birthmark and remarked that the tip corresponded in both size and shape. From the place and shape of the birthmark, she identified him as Chah-Nik-Kooh, a Wrangell warrior, who had been speared to death while

35

leading an unarmed peacemaking mission to the territory of the Sitkas, in 1853.

LAH: *And how young were you when you started fighting?*
BAC: *As young as fourteen or fifteen.*
LAH: *So, do you think you could have been one of these kids here, because this photograph is from Aley, right?*
BAC: *I'm not 100% sure.*
LAH: *But you never looked at the faces in the background and tried to identify if any of them were Youssef al Jowhary?*
BAC: *I try, but it's hard to tell because I don't know how I looked like, and I, till today, still look for my picture, and I can't manage to find anything. Although many of my ex-friends, or ex-colleagues, or ex-fighters who used to fight with me, say, "You may have pictures of you in Aley, if you go up and you search in Aley."*
LAH: *But you don't know what you looked like, though.*
BAC: *No, I don't know what I looked like, so I don't know how to figure out how I looked like or how I'm going to identify myself, unless somebody tells me, "This is you." That's another story.*

Bassel still has very little idea of what he looked like in his previous life. He may have an image of Youssef in his vast archive, but without knowing what he looked like, he cannot identify himself amongst his archive. With the idea that we could try to see if indeed such a picture exists amongst Bassel's collection, I approached Dr. Caroline Wilkinson at Face Lab, a research group at Liverpool's John Moores University that carries out forensic/archaeological research, including craniofacial analysis and facial synthesis. I asked her if she could use the image of Youssef as a six- to seven-year-old child (as

well as reference images of his brother and father) and reconstruct what he may have looked like at seventeen years old. This was the result.

The process she used to create this image is often used in missing persons cases, particularly when someone goes missing as a child. She explained to me that she has had astonishing results—most recently she produced a facial synthesis of a woman from her skull alone. By circulating this image to the public, an old neighbor identified that reconstruction as someone whom she had known and who had disappeared many years prior. This is how the police were able to identify the body.

Dr. Wilkinson explained to me that her success in such cases depends on staying within a tight threshold of recognition. The face has to be both specific enough to elicit the memories of those who have seen the face before, while also generic enough not to overstate any one specific characteristic, for fear of throwing people off the trail of identifying them. It has to be a somewhat generic person's face with just enough signifiers that it could be the person they need to identify. You need to open and activate the interpretive capacities of the viewer. To do this, the faces also have to be somewhat digital. There must be enough digital artifacts, like this intentional pixelation she has placed in the background, to be able to tell that this is indeed an illustration and not a real photograph. For if it is too real, people will not be able to interpret the image as a reference instead of a real portrait.

At the same time, the face cannot be completely digitally rendered, as Dr. Wilkinson needs the public to see this

face as real and as believably human to solicit an urgency
to their gaze. To keep this human threshold, she must use
real human facial features. Each of the features that make
up this image are actually cut and copied out of anthro-
pological archives and photographic databases. To make
her database, Wilkinson collects endless portrait books,
including titles such as *The Berbers: The Peoples of Africa,
Faces of the Zulu, The Atlas of Beauty: Women of the World
in 500 Portraits, Crowns: Portraits of Black Women in
Church Hats, The Photographer's Guide to Posing: Techniques
to Flatter Everyone, The Moment It Clicks, Tibetan Portraits.*
She harvests from these books eyebrows, hairlines, noses,
eyes, mouths, chins, facial hair, and skin textures. She
then intentionally erases the source of these images so
that they become a sea of unidentified stray features
floating away from the faces to which they were originally
attached. She does this to limit her own cognitive racial
bias and focuses only on the distinct feature she feels
would best fit the face she is reconstructing. She also
creates this massive mix so that she will not be tempted
to use too many features from one single face, or she
risks re-creating an incident from an FBI investigation
in 2011. During their search for Osama bin Laden, the
FBI released to the public an image of a synthesized,
older-looking bin Laden. But in doing so they used too
much of the face of Spanish politician Gaspar Llamazares.

Many Spaniards recognized Llamazares in the face of bin
Laden, and Llamazares became enraged, forcing the FBI
to retract the image and apologize. For Wilkinson, this
became a lesson to choose each feature separately. In order
to be able to compose Youssef's face, Wilkinson must look
through her unaccounted catalogue of features before

fixing on the faces of eight people that constitute this one
face. His nose is not chosen out of a selection of Semitic
nose types but is a nose based on his nose at the age of six,
along with the way that his brother's and other family
members' noses developed. His eyes were chosen because,
at a young age, he seemed already to have eyes which sat
shallow in their sockets, eyes where the lids protruded.
Only the lips were significantly altered in Photoshop,
puffed up a little to match the development of lips in
his family.

We don't know if this looks like Youssef, and as yet we
haven't been able to match this photograph with anyone
in Bassel's archive. Youssef remains missing. Though his
memories, whether learnt or unlearnt, whether planted
or transmigrated, are now lodged in Bassel's mind. It is
not empathy which Bassel feels for the trauma suffered by
the generation which preceded his, for empathy suggests
otherness. Bassel's is not the search for understanding,
but is the full embodiment of another person. It is not
that he can feel another individual's pain, but that indi-
viduality itself is undermined. That is why, for me, this
face made of many nameless faces is somehow not the
perfect portrait of Youssef, but is perhaps the perfect
portrait of Natq itself, and the kind of witness it produces:
witnesses who leak into other bodies, who bleed across
generational and potentially sectarian divides, forcing
new pathways to the production of history that have
otherwise been sealed. Bassel can't find what he looked
like because he is not just looking out for himself.

As the de facto political leader of the Druze, a community
of believers in reincarnation, Joumblatt is the least likely

of all of the civil war-era politicians to denounce the validity of such claims. Within the religious part of the community, Natq holds a distinct validity as a form of witnessing.

However, not just anyone can make such claims. There do exist theological protocols that determine whether or not the Natq of returned witnesses is credible. Amongst them, one must, first and foremost, have to have shown distinct signs of xenoglossy, the speaking of events without having learned them, before the age of five. Another is that unless one can find an intermediary life in which the soul transmigrated before that of one's own, the dates of one's birth in the current life and one's death in the previous life must match. In legal terms, this would be called establishing a "chain of custody," the essential chronological documentation that records the sequence of control, transfer, analysis, and disposition of evidence. Everything that is done and whoever came in contact with that piece of evidence must be listed for the evidence to be presented. This protects the evidence from contamination. In this case, it protects the memory. They must ascertain that the memory was touched by no one before it was first uttered by the subject. That the memory is a direct transmigration, not something planted by other means.

The chain of custody in the case of Bassel Abu Chahine is broken. There is a three-year gap between Youssef's death and Bassel's birth. We don't know where the soul went during this time. A generous reading would be that it entered an infant who died at the age of three, while the memories of Youssef were not yet overwritten by their

own life experience, and then, after a peaceful passing, this soul transferred Youssef's memories to Bassel.

Should Bassel's Natq become a threat to the Progressive Socialist Party, this would be their best chance at silencing him. This break in the chain of custody, this unknown intermediary life, would be used to reclassify Bassel's status of witnessing from direct experience to hearsay, thus proclaiming the contamination of his memories, suggesting that they were either learned or planted.

However, seeking to delegitimize Bassel's Natq risks legitimizing Natq itself as a form of testimony. Debating it, even if against it, under the terms of testimony, would be tantamount to admitting that such forms of testimony can be debated politically. This is not direct testimony to a singular event that can be cleanly cross examined, nor an expert testimony relaying specialized knowledge of a specific field whose credentials could be discredited. These are witnesses who testify to ceaseless violence, who have the unique perspective to testify to long and continuous crimes that leak across generations and threaten the future.

So Bassel's missing years make him an imperfect witness, and yet to use this to dissuade people from the validity of Bassel's Natq is to simultaneously open a channel of audibility for a new category of witness... And Bassel is not the only one to return.

walled
unwalled

It was rumored that Danny Lee Kyllo grew the best weed in all of Oregon. In the early '90s, his product was famous for coming with strict instructions: SMOKE ONLY, NO BAKING, NO BROWNIES. It was so strong that a single toke produced a strange high, one that could both settle your nerves and heighten your senses. If you smoked just a little too much, you would start feeling agoraphobic and claustrophobic at the same time. Kyllo's weed found local infamy when a parent reportedly found her teenage son, high as hell, nestled in the corner of his room, gibbering, "I no longer know what there is behind the wall. I no longer know there is a wall. I no longer know this wall is a wall. I no longer know what a wall is. I no longer know that in my room there are walls, and if there weren't any walls, there would be no room." By 1992 the product had spread from the inner city and permeated deep into the suburbs, catching the attention of police officers as it wafted outwards.

Eventually the police received a tip-off to Kyllo's whereabouts. One night, as he was attending to his weed and replacing a bulb in one of his high-intensity heat lamps, the police were outside on a stakeout. With the curtains drawn and no search warrant, nothing unlawful could be detected from the exterior of the property.

A year prior to this stakeout, a law was passed that allowed the police to acquire surplus equipment from the military. Assault rifles, Humvees, choppers, boats, and sniper scopes began transforming police departments into combat-ready infantry units. This is how an as-yet-unused Ajima Vision 2-10 Thermal Imager found its way into the trunk of the unmarked police car parked outside Kyllo's home.

Conscious that it would be considered trespassing if they were to set foot inside the boundary of his private property, the officers crept up as close as they could get. With their legs pressed against the outer surface of the well-worn, waist-high wooden perimeter, they peered through the viewfinder of the military-grade thermal camera. The exterior wall of Kyllo's home appeared to be aflame. The image was saturated with white-hot amorphous blobs that loosely marked the outline of the high-intensity heat lamps beating down on the plants behind the wall.

Kyllo was arrested. Though it would be another ten years until he received his final verdict. His case went up through the entire court system, eventually ascending to the Supreme Court, where Kyllo's hot wall became a matter of constitutional magnitude. The debate came down to one irresolvable technicality: Did the police officers illegally see through the wall into his home, or simply observe the heat as it emanated from the wall's exterior surface? Was the heat that passed through the wall of his home into the air outside public or private property?

The contest in court became like that Orson Welles film, the one where Charlton Heston plays a Mexican and has to figure out if a murder in no-man's-land happened in Mexico or America. Here the internal fabric of the wall became the legal gray area—not between two nations, but between that of public and private space, between the technologies permitted for police work at home and those used by the military abroad.

After much heated debate in their chambers, the judges returned to court and concluded for once and for all this border dispute. Kyllo walked free. It was ruled that anything migrating through a wall—be that liquid, heat, or sound—that was not detectable by human senses unaided by technology was a breach of the border that separates the home from the city, the private from the public. A line in the sand was drawn, and this trial set a precedent that meant Kyllo's wall became a legal barrier for all US citizens. It has since been invoked to protect the information stored behind the screen of your phone and even behind the membranes of your skin. While the police continue to buy technologies designed to make Iraqi and Afghani walls invisible, and Iraqi and Afghani bodies transparent.

Kenneth Lerner: "I think that's a very dangerous road to go, when we start talking about imagers and technology, because what it's capturing really is molecular information that migrates through our walls, and therefore, if we are now saying that we can capture that kind of information without a warrant, we can reduce our whole world to that type of wave and molecule and our walls mean nothing."

In the year 2000, construction began on tens of thousands of kilometers of border wall. It was to be called the Great Belize-Guatemala, Botswana-Zimbabwe, Brunei-Limbang, Bulgaria-Turkey, Morocco-Spain, Costa Rica-Nicaragua, China-Korea, Egypt-Gaza, Estonia-Russia, Macedonia-Greece, Malaysia-Thailand, Hungary-Serbia, Hungary-Croatia, India-Bangladesh, India-Burma, India-Kashmir, Iran-Pakistan, Israel-Area C, Kazakhstan-Uzbekistan, South Africa-Zimbabwe, Pakistan-Afghanistan, Saudi-

Yemen, Saudi-Iraq, Slovenia-Croatia, Turkey-Syria, Turkey-Iran, Turkmen-Uzbekistan, Uzbekistan-Afghanistan, Ukraine-Russia, UAE-Oman, Mexico-United States Wall.

As these walls were being constructed, millions and millions of invisible cosmic particles called "muons" descended into Earth's atmosphere and penetrated meters deep, through layers of concrete, soil, and rock. Scientists realized that these deep-penetrating particles could be harvested, and a technology could be developed to use their peculiar physical capacities to pass through surfaces previously impervious to X-rays. Muons allowed us to see for the first time the contraband hidden in lead-lined shipping containers and the secret chambers buried inside the stone walls of the pyramids. Now, no wall on earth is impermeable. Today, we're all wall, and no wall at all.

"And to me, the cry, my lady, it was a cry of pain."

"May I ask you this, Miss [unintelligible], was the crying soft, loud, low pitch, high pitch?"

"The crying was very loud and very close. I even thought it could be inside the house. It was very loud and very, very close."

"And the pitch of the cry?"

"It was very loud."

"When I consulted with you, I asked you if you could just
make [unintelligible] resembled that noise? I know it
won't be as loud, but just to give the court some idea of
what you..."

"The crying was like: *huuuuuuuuoh wooooah*."

On Valentine's night 2013, in Pretoria, South Africa,
Michelle Burger awoke to the sound of a woman screaming,
followed by a volley of four gunshots. She re-created the
screams she heard that night in a court of law when the
event she witnessed became the subject of a murder trial.
The trial of the athlete Oscar Pistorius was dedicated to
discovering if he had intended to kill Reeva Steenkamp
through the bathroom wall or if it was an accident.
Pistorius testified that he believed he was shooting at an
armed intruder behind the wall when he shot Steenkamp.
The wall became the last line of his legal defense. Accept-
ing that he could not see through the wall, the attention
of the court turned to how permeable the structure was
to the sound of her voice.

The wall was built from twenty-centimeter-thick concrete
masonry blocks, through which a scream would likely lose
many of the frequencies that contain the distinct charac-
teristics of a human's voice. However, the bathroom wall
had a bathroom door, and the bathroom door was a
three-centimeter-thick medium-density fiberboard with a
millimeter-thin veneer. This door is not only weak enough
to allow a sound of that intensity to pass through its fibers,
but of the frequencies it is able to block, absorb, and deflect,
it is weakest at preventing the low- to mid-range frequen-
cies of the human voice from passing through. The dip of

49

the door's acoustic absorption perfectly matched the peak intensity of Steenkamp's scream. The weakest point of the weakest point of this wall was a hole perfectly sized for a female voice to squeeze through.

The door and the wall filtered her voice, but in doing so intensified it, blocking entirely his capacity to see her, yet paradoxically amplifying the clarity at which he could have heard every idiosyncrasy of her scream.

"My name is Ronald Reagan. Last year the contributions of 16 million Americans to the crusade for freedom made possible the World Freedom Bell, symbol of hope and freedom to the Communist-dominated peoples of Eastern Europe, and built this powerful 135,000-watt Radio Free Europe transmitter in western Germany. This station daily pierces the Iron Curtain with the truth, answering the lies of the Kremlin, and bringing a message of hope to millions trapped behind the Iron Curtain. [...] Remember, the Iron Curtain isn't soundproof. Radio Free Europe gets the truth through."

During the Cold War, radio waves were used to transgress the thousands of kilometers of border wall that divided Europe. The forces of the West built broadcast stations in Munich and Lisbon, while here, in the east of Berlin, the Soviet Bloc constructed a huge radio recording facility. This was the largest complex of radio studios in the world at that time. It was dedicated to creating radiophonic propaganda that could leak throughout the Soviet Bloc, seep through the Berlin Wall, and bleed into the apartments in the west of the city.

50

In their day, these sound studios were the most advanced example of radio architecture, in which almost any acoustic world could be conjured. The floors were divided into multiple surfaces in order to be able to create the sound of footsteps on gravel or wood, marble or sand, snow or tiles. Creating the sounds from outside, inside. Rooms in which an arrangement of modular partitions could create acoustic spaces of any shape and size. Rooms where the walls themselves could revolve, transforming between different surfaces that could reflect and reverberate the rich diversity of life on the other side of the wall.

During those same years the East German Republic also perfected the acoustics of incarceration. Building a prison where the walls were used as weapons; creating prisoners who see nothing but hear everything, who are both completely confined and yet totally exposed. They exported and built this archetype throughout the '60s and '70s in the Eastern Bloc, Colombia, Angola, Egypt, Lebanon, and Syria. The combination of its German origins and its three-pronged star design meant that wherever it was built, they locally referred to it as the Mercedes-Benz of prisons. In 2016, I learnt the full extent of this acoustic architectural design when I began an acoustic investigation into a prison that was modeled on this GDR archetype.

The Mercedes-Benz of prisons in Syria, the one I investigated, is called Saydnaya. Since the beginning of the 2011 protests, the regime has used it as a torture prison and execution center. The prison is inaccessible to all except those detained there and those detaining them. The only way to access what's happening inside its walls is through the memories of a small selection of detainees who were

one day unexpectedly released. These survivors were blind-folded as they entered and exited. Most of them never left their cell for the entire period of their imprisonment, and so they only ever saw the four walls of that cell. Like prisoners all over the world, they got to know these walls intimately; every crack and fissure can be identified as they run their eyes over the topography of the concrete surface again and again and again. With these walls becoming the limits of their visual world, they had to train their ears to surpass them, listening to every sonic sign and signal to try and gather as much information about the place in which they were incarcerated, the people who were incarcerating them, and the forms of torture they were being subjected to.

For a sound to vibrate the walls of a room from two stories above through the security-grade thick-concrete structure, it would need to be of a magnitude that no human strike could create. And yet all of the witnesses insisted to me that the walls of their cells shook from the beatings that took place in distant and unlocatable areas of the prison. Later I understood why. The shape of the building, the dimensions of the corridors, mean that sounds made in the cells are reflected towards the central tower. This is a listening tower, allowing the guards positioned here to hear everything happening in all the cells across the three wings. This listening tower has a staircase spiraling all the way from the basement to the roof, which creates an opening, and so a great column of air stands in the center of this building. All the sounds made in the prison are by design directed towards this listening tower, making this column of air act like a huge megaphone, funneling and forcing sounds throughout the three wings in ways that defy proximity. The sometimes-shrill hiss of a whisper

spoken in cell A, wing 3 could be heard louder in wing 2, for example, than in its neighboring units.

There was one sound, however, that, wherever it occurred, all the cells in each of the three wings would hear it. This was the sound of the thick green plastic plumbing pipe striking a human body. As it is completely forbidden in Saydnaya to utter a sound of pain when one is being tortured, witnesses heard only the sound of this half-centimeter-thick pipe with a four-centimeter hole in the middle striking a corporal surface. At the moment of its percussion, the vibrations catapult the air out of both ends of the hollow pipe, creating a blast wave, like the gases firing out of the muzzle of a gun. The walls shudder, not from the force of the strike, but from the blast's resonance. This sound then fires out of the cell, funnels into the column of air, and spirals around the central listening tower, where it becomes broadcast throughout the prison, from the group cells on the third floor to the solitaries in the basement. As it dissipates it loses the initial crack of its impact, and what is left to bleed into the cells below is a muddied thud. A muffled low–mid frequency booms through the prison at 250 Hz, the exact frequency at which the walls of Saydnaya are built to vibrate. By the time the sound of torture reverberates in the lower floors and distant wings, it becomes dominantly felt as a vibration rather than heard as a sound. As torture rings through the porous and yet inescapably solid membranes of this structure, "it doesn't sound like something is hitting a body," Jamal explains, "it feels like someone is demolishing a wall."

air
pressure

May 2020: 148 violations of Lebanese airspace by the
Israeli Air Force. 101 unmanned aerial vehicles,
46 fighter jets, and 1 drone. Total flight time: 453 hours
and 40 minutes.

June 2020: 195 violations of Lebanese airspace by the
Israeli Air Force. 146 unmanned aerial vehicles,
38 fighter jets, 10 drones, and 1 balloon.
Total flight time: 679 hours and 42 minutes.

July 2020: 440 violations of Lebanese airspace by the
Israeli Air Force. 384 unmanned aerial vehicles,
42 fighter jets, 12 drones, 1 helicopter, and 1 glider.
Total flight time: 1,976 hours and 49 minutes.

August 2020: No data.

Since 2006, a total of 243 letters have been submitted to
the UN Security Council by the permanent representative
of Lebanon. These documents contain the data on every
Israeli Air Force violation over the last fifteen years: the
time, duration, trajectory, and type of aircraft that entered
Lebanese airspace. All this information had been uploaded
to the UN Digital Library and was just sitting there. Well,
not exactly sitting there. More like spread all over the place.
The first document I found detailed all the violations for
a three-month period in 2007, then another detailed all
the violations for May 2016, then that led me to another
in 2009, and then from there to another, and another, and
another, until I logged almost every single month.

For the last two years, I've had my head buried in these
documents. Downloading, reading, transcribing, and

compiling all that I could find. So much so that the data began to integrate into my life. The most F-35s I counted in a single day was the day of my PhD professor's fiftieth birthday party. On the day my daughter was born in Beirut, an unmanned aerial vehicle circled the south of the country for two hours and thirty-five minutes.

Some of these flyovers last one minute, while others circle for thirty hours. Some are agricultural crop sprayers, a few are balloons, but most are unmanned aerial vehicles, or what are more commonly known as drones. Fighter jets come in a close second. Few fly so low and so fast that they break the sound barrier, shattering windows. But most work to activate the background. Their noise hangs in the atmosphere, stirring at the threshold of audibility. Not loud enough to be terrifying, but frequent enough to fuel a near-constant dread.

It took me seven months to harvest all the data I could find from the UN Digital Library. And just when I thought I had amassed everything in one place, I noticed a gaping hole in my collection. The data for the month of August 2020 was missing. August 2020 was the month of the ammonium nitrate massacre, the month when hundreds of people said they heard planes just before the explosion.

Through a journalist friend I get the contact of Amal Mudallali, the Lebanese-government-appointed envoy to the UN. I write to her, asking why this data is missing and if she can supply it to me so that I can complete my research. I get no reply. I send a reminder. Still nothing. I make the demand public on Instagram. The post is shared twenty-five thousand times in seven hours. And

then the data appears. It becomes known to me not because the hole in the digital archive was suddenly filled, nor because someone in the UN sent it to me, but because the link to the August data began to be posted to social media by anonymous accounts, usernames with zero followers, zero following, and zero posts. I don't know who farmed these trolls, but they were meticulous, dropping the link deep within the comments section, doing this at almost every main source where my post had been shared. And from the background, the noise of the data's appearance started to propagate and swell to the surface and eventually land in my DMs.

I drop everything and open the August data and scan to the aerial events of August 4, the day of the explosion at the port. A total of thirty-one airspace violations on that day. Of these thirty-one violations, two were unmanned aerial vehicles in the airspace at 6:07 p.m., the time of the explosion, but they were circling the south, some one hundred kilometers away from the blast.

If the Lebanese Ministry of Defense knew that there were no Israeli aircraft in Beirut at the time of the explosion, then why had this information not been released? Why let thousands of people believe that the noise they had heard before the explosion was jets? Why have trolls disseminate this information from the shadows?

While Israel is using the roaring noise of its fighter jets to exert territorial dominance over Lebanon, various factions of the Lebanese government are using the noise of layers upon layers of atomized, unverifiable, competing half-truths to subjugate and separate the very same population.

I too had become inextricably part of the noise that I was trying to decode. My Instagram post had become a cesspit of conspiracy theories and deeply unscientific assertions. I had sought to produce clarity but instead became just another sound in an ecology of noise: sucked into a cloud thick with the *tak hanak*[1] of misinformation on social media, with the droning B-flat of unmanned aerial vehicles, with the low-frequency hum of electricity generators, with the vapid slurs of a dozing president, with the rapid, head-splitting rattle of water supply trucks, with the loud silence of Hezbollah, with the needless window-shuddering propellers of Lebanese army helicopters, with the tactless combustion of the Iftar cannon, with the annual threats of annihilation issued by IDF commanders, with the indelible sound of sweeping glass, with the...

September 2020: 375 violations of Lebanese airspace by the Israeli Air Force. 320 unmanned aerial vehicles, 40 fighter jets, 10 drones, 4 helicopters, and 1 glider. Total flight time: 1,674 hours and 24 minutes.

September 1. "On the occasion of the first centenary of the proclamation of the State of Greater Lebanon, and in conjunction with the visit of French President Emmanuel Macron to Beirut, a French air squadron of ten Alpha Jets will perform an air show on the first of September at 9:30."

Though this announcement preceded the air show, the ten French Alpha Jets had noisily arrived in Lebanon some six hours prior to the release of any information about what, or who, they were. These were planes no one

had ever seen before, flying lower and slower than anyone was used to—this primed people for a wholly new kind of attack.

In the month before, 451 Israeli aircraft violated Lebanese airspace, which is almost 60 percent more than the August of the previous year. This hugely intensified presence of violent aerial machines had turned the sky against those who lived beneath it. And yet, Macron thought that this would be a great way to boost Lebanese morale and patriotism—to create a Lebanese flag out of the vapor trails of French fighter jets in a sky occupied by the Israeli Air Force.

Military aircraft in the sky have never seemed to stop impressing us as a species. The affective dimension of these machines often outweighs their ability to inflict material damage. Documents from World War I show that the British colonial strategy was to use aircraft more for "the threat of bombardment than actual attack." To broadcast violence across a populace rather than to hit specific targets on the ground. While a Boeing 747 passenger jet can be heard over eighty-seven square kilometers, most fighter jets today have an audible radius of five hundred square kilometers.

In one of the very first documented hearings of combat aircraft by civil populations, Zhenia Selenia describes hearing warplanes in the air above her village in Belarus: "Suddenly small black planes popped up from somewhere," she says, "something was rattling and booming. The strange noise reached the ground as if someone was tearing oilcloth or linen fabric so loud."[2] This sound

seared into Selenia's memory was not just in the air above her but was tearing open the sky itself.

It would be hard to find someone in Lebanon who can remember with such distinct clarity the first time they heard an Israeli Air Force jet above them. They are of such regular occurrence that their presence has become a familiar and routine act of terror. A once-spectacular display of violence has receded into the background, no longer tearing the sky open but suturing a new sky above our heads.

October 2020: 187 violations of Lebanese airspace by the Israeli Air Force. 134 unmanned aerial vehicles, 48 fighter jets, and 5 drones. Total flight time: 734 hours and 7 minutes.

November 2020: 77 violations of Lebanese airspace by the Israeli Air Force. 29 unmanned aerial vehicles, 44 fighter jets, and 4 drones. Total flight time: 182 hours and 2 minutes.

December 2020: 126 violations of Lebanese airspace by the Israeli Air Force. 69 unmanned aerial vehicles, 50 fighter jets, and 7 drones. Total flight time: 257 hours and 2 minutes.

December 25. At around 12:30 a.m., after Christmas Eve celebrations, four Popeye Turbo cruise missiles were launched from an Israeli submarine just off the coast of Beirut. Though these missiles headed directly toward the city, they would eventually explode in Masyaf in western Syria. Traveling around 110 meters above the ground for

160 kilometers up the coast, these missiles could be heard across the entire country. The Israeli Defense Forces claim that they hit an Iranian research center. The Syrian regime claims that their air defense confronted the hostile missiles and shot down most of them. There is no verifiable information about what the missiles struck. We can only account for what we heard that night above Lebanon.

One earwitness, Radwan Abu Touq, listening from his home in Tripoli, says he heard "an explosion like thunder after midnight and it lasted for about forty minutes. I was in great fear. Then when it became clear that the rockets were not landing in Tripoli, we no longer paid attention to the sound." Abu Touq seemed to be applying the principle of "you never hear the shot that kills you"— which is kind of true, unless of course it kills you really slowly.

The score for Albinoni's Adagio in G Minor was in tatters when it was picked from the burning rubble of the Saxon State Library. The building was destroyed in the 1945 bombing raids of Dresden by the British and American air forces. And yet this score would go on to have an extended relationship with aerial warfare. In 1989 it was used in a study into the health effects of low-flying combat vehicles. While they listened to Albinoni's Adagio, subjects were exposed to loud, intermittent bouts of flight noise through headphones. During these sudden interruptions in the music, participants' blood pressure and heart rates were monitored.

The study was initially commissioned by the German Ministry of Health. At that time the sky above West

Germany was continually populated by the noise of American fighter jets. As Germany was still not a fully sovereign nation, the atmosphere was the de facto property of the US military. The West German airspace was divided into low-flight zones. The population of Ramstein experienced the loudest and lowest flyovers, with jets going as low as seventy meters above the ground.

Predictably, the Americans branded this almost-deafening noise as the "Sound of Freedom," but by the late '80s it had become the number one complaint throughout constituencies of West Germany.

Dr. Hartmut Ising, a noise-pollution specialist, was tasked by the Ministry of Health to conduct the study into the potential health effects caused by these jets. From his first studies on the residents of Ramstein, it was clear that the rapid-onset noise of low-flying combat aircraft was increasing cortisol levels, heart rate, and blood pressure. In the long term, these symptoms could cause the thickening of the walls of arteries, increased calcium deposits in the heart, and strokes.

But just as Ising was beginning to collect these observations, his work was abruptly shut down. It is unclear if it really was the human trials that the minister of defense, Manfred Wörner, objected to, or if he was protecting US interests. When he heard of this work, which could limit US aerial activity, Wörner extolled, "This is like the human experiment of Mengele in concentration camps. We cannot allow this." Having been associated with the darkest chapter in German science, Ising had no choice but to conduct his trials elsewhere.

And that elsewhere was Israel. An old-people's home in
Haifa gave Dr. Ising free rein to continue his human
trials. That is, until one of his subjects had an almost-
lethal forty-millimeter blood pressure increase after being
exposed to jet noise. Ising's experiments, and, by virtue,
the sound of these military aircraft, were ordained
threatening to life. He hastily returned to Germany,
armed with overwhelming evidence of the health effects
that these jet engines were inflicting through the ears
and onto the heart. This time the members of parliament
listened. They wrestled the issue out of the auspices of
political sovereignty and deemed jet noise an aural
epidemic. The Americans were no longer allowed to
conduct low-altitude flight training over West Germany.
They swiftly moved their exercises to Goose Bay in
Canada, returning West Germany its sky.

As I read his study more than thirty years after it was
published, one of Ising's observations rang louder in my
ears. He observes that once subjects have been exposed
to noise from low-flying jets, even if the military aircraft
sounds they hear are reduced to just a murmur in the
distance, they experience the same physiological reac-
tions as they do when the sounds are very loud. This feels
all too familiar. It's like I am reading the blueprint for
exactly the kind of acoustic conditioning and weaponi-
zation of sound that is enacted by the Israeli Air Force
today in Lebanon. Now, I have no evidence of a link
between Ising's study conducted in Israel and the
strategies employed by the Israeli jets and drones today.
But it becomes hard for me to ignore the coincidence
when I hear the sky rumbling, and feel the pressure of
my blood rising.

Today the airspace has become a testing ground, not only for psychological operations but for the F-35 itself. The United States, the United Kingdom, Italy, the Netherlands, Australia, Norway, Denmark, and Canada invested $400 billion into the production of the F-35. The Foreign Military Sales customers Israel, Japan, South Korea, Poland, Belgium, Singapore, and now Germany have purchased the vehicle at $100 million a plane. These jets come with strict guidelines from the Pentagon that specify no modifications, no additions, and no deletions, and state that only US-run facilities can service or repair the planes. These rules apply to everyone who invested in or bought the jet except for Israel. Israel was the first country the aircraft was delivered to, and the only country allowed to install customized software and weapons systems. This is because Israel has the most real-world opportunity to test and therefore adapt the F-35 for the benefit of all the militaries who contributed to the $400 billion pot.

When I learn this, I no longer see the sky above me as aerial wasteland where fighter jet pilots joyride, but rather as prime real estate. Four hundred billion dollars of air. Incidentally, that is $100 billion more than what many scientists predict is needed to reverse the entirety of the climate catastrophe. These jets literally cost the earth.

January 2021: 104 violations of Lebanese airspace by the Israeli Air Force. 43 unmanned aerial vehicles, 58 fighter jets, and 3 drones. Total flight time: 204 hours and 20 minutes.

January 6. Lebanon announced a twenty-five-day lockdown to stop the advancing spread of COVID-19. The airport was closed, and yet the skies above Beirut were as loud as ever: not with the hum of passenger planes, but with a persistent buzz. The whining *heeeeeeuuuh* of an unmanned aerial vehicle, the Israel Aerospace Industries' Eitan. Though UAVs have caused mass destruction and killed an uncounted number of people in Pakistan and Somalia, in Lebanon these vehicles have been used primarily for surveillance. Which means the sound is differently felt. When this same sound is heard in Waziristan, people run for shelter. Waziri drone survivor Saeed Yahya describes the sound of the drones as "a wave of terror." In Lebanon the reaction is more one of annoyance at a machine that, though incredibly lethal, is for now just ... whingeing ... incessantly whingeing. Whingeing in A-sharp.

But can this whining in the sky act like a sonic search-light indicating the otherwise hidden movements of the Lebanese deep state? When the UAV circles a specific neighborhood, I speculate that Hezbollah might be moving something in or out. When I hear it drifting up and down the coastal highway, I imagine that it is follow-ing some convoy carrying an Iranian VIP. But when I hear the sound over my head, I suddenly feel exposed. Especially this time of year, when there is the lowest amount of water vapor in the atmosphere, making for the clearest, most high-resolution aerial photography.

You would think that this would be the time of the most concentrated Israeli Air Force activity, that they would take advantage of January's thin atmosphere to gather

their images. But they don't: January is consistently the quietest time of the year. Each summer the Israeli Air Force intensifies operations by at least 10 percent. During June, July, and August, there is three times the amount of water vapor in the air. This atmospheric haze submerges aerial photographs behind a milky surface, making it very difficult to see what is happening on the ground. And yet during the summer months the sound of UAVs becomes more present. The density of the summer atmosphere means the higher frequencies are louder and can travel further. Just in time for tourist season, the jets and drones collude with the humidity, piercing deeper into the lives beneath them.

February 2021: 94 violations of Lebanese airspace by the Israeli Air Force. 64 unmanned aerial vehicles, 17 fighter jets, 8 drones, 2 helicopters, and 3 gliders. Total flight time: 221 hours and 16 minutes.

March 2021: 82 violations of Lebanese airspace by the Israeli Air Force. 45 unmanned aerial vehicles, 24 fighter jets, and 13 drones. Total flight time: 187 hours and 10 minutes.

March 21. At 8:58 p.m., two lights appeared in the sky. They hung there, in silence, glowing. Not discernibly descending, but I suppose they must have been, as there is no other architecture from which they could have been suspended. Despite all their capacities for night vision, Israeli border police were reportedly using these flares to light their way as they intercepted three Sudanese migrant workers illegally crossing from Lebanon into Israel. These people are running from rampant inflation.

As the Lebanese lira liquefies, the state dissolves and its borders disintegrate. By sea, people overcrowd dinghies; by land, metric tons of pomegranates stuffed full with Captagon tablets drip down the Arabian Peninsula. And even the subsurface crumbles with hundreds of meters of informal pipelines flushing diesel into sanction-stricken Syria. While the territory vaporizes, the sky appears paradoxically solid. Like a hardened piece of infrastructure capable of supporting these flares and the 22,111 Israeli jets and drones that have entered it since 2007.

April 2021: 98 violations of Lebanese airspace by the Israeli Air Force. 72 unmanned aerial vehicles, 20 fighter jets, and 6 drones. Total flight time: 295 hours and 29 minutes.

April 30. Six hundred metric tons of carp corpses floated up to the surface of Lake Qaraoun, Lebanon's largest artificial reservoir. Though the fish in the lake had been dying routinely, this annihilation on a mass scale—and of carp, a type of fish that is known to adapt well to harsh environments—was unprecedented. The Litani River Authority and the Society for the Protection of Nature in Lebanon concluded that the deaths of all these fish resulted from an as-yet-unknown viral epidemic. But six months before, on October 22, 2020, at 6:05 p.m., two Israeli fighter jets entered Lebanon over eastern Bekaa. One of these planes dropped an unidentified object into Lake Qaraoun. What did they drop into the lake? No idea. And yet, it is highly possible that whatever they dropped in there had nothing at all to do with the uninhabitable state into which the lake's waters descended. Lebanon is perfectly capable of having made that lake uninhabitable

all on its own. "Lebanon's situation is shaky. We can make it even shakier," says Benny Gantz, the current Israeli minister of defense, describing the strategy to target the pressure points where the Lebanese state is already failing its people. Seamlessly incorporating his jets and drones into an already toxic atmosphere.

"7arbi bi ajawa2 fo2 beirut?" tweets @Louisduffleback.[3] @true_whitewolf replies straight back: "I'm hearing some, but not sure because *mafee kahraba*[4] and all the generators are on around me, so am not sure about where the sound is coming from." Earlier this month the Lebanese state dropped its electricity supply from nineteen to fourteen hours daily. These blackouts have meant a vast increase in the use of diesel-powered engines to generate electricity for homes and neighborhoods. The result is noise. Beirut is rumbling: if you go five floors up and listen to the acoustic horizon, it feels like the whole city is one large revving engine that is about to take flight. Each generator produces around seventy decibels of engine noise, the same intensity at which we usually hear the fighter jets. What makes this even more disorienting is that the two engine noises also occupy the same frequencies, so it is hard to tell what's a generator and what's a fighter jet. The sound of two lethal entities, state-sanctioned corruption and enemy invasion, now mask one another. We can no longer tell where one enemy ends and the other begins. Seventy decibels plus seventy decibels equals seventy decibels. Noise pollution does not accumulate as much as coalesce. If we extract only one of these noisy toxins, the air will remain just as polluted as it was before. The only way to live in peace is if we remove all these sources of noise from our atmosphere.

Kilon yaani kilon.[5]

May 2021: No data yet.

There is about a three-month lag between the data being submitted to the UN by the Ministry of Defense and its eventual collation and submission to the UN's digital library. But even without the data I can tell you that the violations this month have dramatically and suddenly decreased. This is the only flight I heard and documented during that month. The skies are suddenly and eerily silent. This realization is not a comfort. The silent skies of Lebanon are the direct result of the intensified bombing of Gaza. Our air is quiet because those same aircraft are realizing their maximum capabilities for sonic and material destruction elsewhere. It is in the silence that we hear just what these vehicles are capable of.

Epilogue:

June 30. The Lebanese army announced a fundraising campaign to sell fifteen-minute rides in military helicopters for US$150, cash only. I book and go. I arrive at 9:00 a.m. for a 9:20 flight, and we are still waiting to board at 10:30. Various pilots, soldiers, and officers pass me by as I wait. One shouts, *"La2 tkhafo,*[6] we are four hundred flights deep and no one has vomited yet!" Finally we get word that the chopper is on its way. The flight safety briefing begins. We can't watch the safety video on the TV because the air base currently has no electricity, so a soldier improvises, playing it for us on his phone. Moments later the helicopter comes in to land, and I take out my decibel reader. These helicopters

generate almost ninety-five decibels, around twenty decibels louder than the level at which we usually experience the Israeli fighter jets. The skies just got a lot louder, and this time, it's the Lebanese army adding more rattling clamor to the atmosphere. Up, down, up, down, all day, six days a week, these helicopter groups take off one after another from four different air bases around the country.

They may not be equipped to protect the population, but their equipment can give you a nice day out. And I mean that sincerely. It was an uplifting experience. For the short while that I was up there, I looked down as I have been so often looked down upon. I was the noise in the atmosphere, and until I touched down again, all the other noises of life in Lebanon were mute.

1. Literally, "cracking jaws" or "talking nonsense."
2. Svetlana Alexievich, *Last Witnesses: Unchildlike Stories* (London: Penguin Classics, 2019), 31.
3. "Is the war in the atmosphere above Beirut?"
4. "There is no electricity."
5. Translated as "all of them means all of them," this term was popularized and chanted during the 2019 uprisings against the Lebanese government and its use of sectarianism as an agent of corruption to divide the people. This slogan galvanized people and brought them together regardless of religious sect or identity. Under the umbrella of this term is an understanding in popular culture that it is not any one particular person or issue that needs to be targeted, but a whole system of kleptocracy, violence, and sectarianism that must be brought down.
6. "Don't be scared."

a
thousand
white
plastic
chairs

My great-uncle Farhan was known for stealing the stories of others. He was so shameless about it that when he self-published his autobiography, all the villagers were shocked to read that he had appropriated their late uncles' war tales, that he pilfered their dead fathers' adventures as a student living in Europe, or that he stole their long-passed grandfathers' business acumen from Saudi Arabia. The strange thing is that Farhan was not a famous man—there was no audience for his book outside the village—and yet everyone in the village who read the book knew that those stories did not belong to Farhan.

Perhaps this was why there was an unusual and disrespect-ful level of noisiness and chatter at his funeral. No one put their phones on silent, and many would turn in their chairs and shout across the room to friends many rows back. Throughout all this clamor the family stood facing the attendees like a wall of silence. They received the guests one by one with a stern solemnity before watching them disappear into the cloud of unbefitting chatter.

My uncle and I sat amongst the ringtones and loud saluta-tions, muttering to one another in a hushed tone, too closely related to the deceased to partake in the cacophony. Despite the disarray, somehow a sign that the open casket was ready to enter the room networked its way through the crowd, like ice freezing everything in its path.

Ironically it was me and my uncle, speaking in what we assumed to be a conscientious whisper, that were among the last to become aware of the sudden change in the room's acoustic temperature. We had barely noticed that the room had fallen silent until our voices, once the most

hushed in the room, were suddenly amplified to the loudest. I turned my head away from my uncle to face the silence, and at that moment my ears were suddenly met with a dreadful sound: one thousand white plastic chairs scraping the tiles as they were picked up, dragged, and stacked on top of one another in rows that lined the four walls of this vast multiuse municipal hall. This clearing of the chairs was to make way for the casket and to ensure the attendees stood in respect of the dead. Its physical amplitude was vast, but what made it more punishing was its object quality; its coarse, low, granular groan was accompanied by a whistled scrape that seared up and beyond the frequency spectrum of what is humanly audible.

This eruption was fleeting. While we were in the lingering cloud of its reverberations the attendees had fallen back to the silence that preceded it. This horrific sound, buttressed by silence, has stayed with me ever since. Though I saw his corpse that day, I can no longer really recall how he looked, what he was wearing, how his face was exhibited, and yet the sound that preceded his image is etched into my cortex.

In 1968, Alistair Cooke, the BBC correspondent to the US, was one of many witnesses to the assassination of Bobby Kennedy. His account included an unusual detail. He said that "there was suddenly a banging repetition of a sound that I don't know how to describe: not at all like shots—like somebody dropping a rack of trays." Even after the fact of him knowing that what he had in fact heard was gunshots, he still retained the sonic image of the rack of trays as a central part of his testimony. Even

after he saw Bobby Kennedy lying on the ground, felled, he continued to negate the sound of gunshots and speak only of the tray rack. It was as if the rack of trays was a kind of buffer to reality, the last thing standing between what actually happened and an imaginary realm of alternate scenarios where what happened never happened. It seemed that he, too, was unable to forget the sound that preceded the appearance of the dead.

I have since come across many similar examples where benign objects stand in place of the facts of the event itself. "It didn't sound like a punch, but a lighter being thrown to the ground and popping," said a witness in an Oregon courthouse. A New Zealand witness said of a blow he overheard that it "sounded like an egg cracking." Sometimes, as in the case of the egg, the objects are repeated during the testimony with such frequency that it becomes seemingly impossible for the witness to uncouple the sound of an egg, indeed the apparition of the egg itself, from the violent event they witnessed.

It is not so much the information about the event but the process of encoding and recalling such events that become stored in these objects. The sound of the rack of trays or the egg does not capture the event itself, but they petrify the moment of the event's mental processing. These objects allow us to remain with the event at the first moment it entered the mind's ear of its witness. These objects become a relic of the split second between the event and its reckoning.

This split second can endure for years and years before the event is reconciled for what it in fact was. There was

an eight-year gap before the translators of the Nuremberg trials finally began to speak and write about what they had heard and translated. "One gets so attached to the wording that one does not notice the content," Henry Lea, a Nuremberg translator, explained. "Only years later one awakes gradually and realizes the content that had been registered somewhere subconsciously." This meant that the monstrosities of the Nazi war criminals that were translated by the Nuremberg interpreters became conscious to the interpreters themselves only with a delay in time. This lapse in time was perhaps due to the fact that a partial elimination of their consciousness was required to make the task of simultaneous translation possible. They had to listen to other people's voices while they were speaking themselves, and to do this had to become somewhat machinic. Interpreters have to react to spoken words with interpretation at reflex-like speeds.

The simultaneous translators did have one instrument to slow and pause the speed of the sound that flowed into their headphones: a yellow and a red light bulb built into the witness stand and the prosecutor's podium. The interpreter in a room adjacent to the courtroom could control these lights; flashing the yellow light once signaled the order to "speak slower," while three quick pulses demanded the speaker raise their voice. One red flash indicated that a sentence needed to be repeated, that an utterance was incomprehensible or untranslatable. These lights became somewhat of a rude interruption; the judges despised them because it removed their autonomy to control the speaking subjects in their court. Similarly, the Nazi perpetrators loathed them because they could not conceive of the hierarchical inversion in which a

translator is permitted to instruct and interrupt a general. The witnesses hated them because the lights illuminated moments of vocal inadequacy; be it a signal that they were too quiet or too fast, it reminded them of the tremendous scrutiny with which their voices were being heard. And heard not only inside the courtroom but relayed radiophonically to a world well beyond the walls of the courthouse. In this mass media event the lights exposed moments in which they became unintelligible; the flare of the red light emblazoned their faces at the moments when they struggled most to make what they had seen speakable.

The translators were used as a technology to facilitate across Russian, English, German, and French, but they were not themselves part of the historical record. We have no recordings of the voices of the Nuremberg translators in the act of translation. The only record of their presence is the red and yellow light bulbs silently flashing in the filmed footage. When we cross-reference the moments where we see these flashes with the trial transcript, we quickly notice that these illuminated interruptions have been deleted. Though we can hear the system being discussed on the original recordings, in the trial transcript there is no record of such moments as when the flashing of the red light, the order to repeat, totally derails another witness's train of thought. Or how the judges step in to decode the meaning of a flashing yellow light that dumb-founds a witness on the stand. In the transcript of the trial, the relay from voice to voice appears as a smooth and seamless passage. The task of the stenographer, then, is to free testimony from its very sounding. To clean it of its shuddering issuance. To render historically inaudible

the inner contest between the intention of an utterance and the act of its uttering.

I once met with a court stenographer in London and he described to me that in order to transcribe at the speed of speech, one has to enter a state he termed "autopilot mode." To access this plane of consciousness, trial stenographers find a single ornamental architectural detail in the room. Perhaps it's the top right corner of the window cornice or the beveling of an architrave or the point where the crown molding meets the ceiling. While their eyes scan every centimeter of this object, a preconscious channel opens up between their ears and their fingertips. This not only allows them to type at the necessary speed, but also creates an acoustic force field to protect them from the otherwise heavy labor of having to spend days and days listening to content which can often pertain to violence and fatality.

Courtroom stenographers are becoming increasingly rare in criminal trials in the US, Australia, and the UK. This is not because their labor is becoming automated, but rather outsourced. More and more criminal trials are being audio recorded, and these recordings are being sent for transcription to a collection of companies based in the city of Ahmedabad, India. A perfect combination of reduced labor cost, time difference, and a shared common-law legal system enforced on India during British colonial rule makes India the ideal candidate to transcribe the trials of their former colonizers and their former colonizers' former colonies.

What saves them more money in this context is that no special training is required for the stenographer. As they

are not transcribing in real time, these typists need not know how to enter the stenographic "k-hole" that allows them to type at the speed of sound. They can simply pause and rewind the recording to make sure each word is recorded in the transcript as it was spoken. This means the transcribers in Ahmedabad personally retain much more of the content of what is being spoken in trials. The pause button creates a portal, an opening through which a cacophony of maligned voices directly flows into comprehension. The pause and rewind buttons inaugurate new conditions of labor for the transcriber.

Although they are geographically much further away from the voices of the courtroom, they are somehow much closer to the testimonies than the stenographer who sits just meters away from the witness stand. There is also a paradox in time: while the pause and rewind buttons slow the overall labor, they accelerate the time it takes for the information to become envisaged. The Gujarati transcribers have no acoustic force field, no architectural ornament, no eight-year lapse of subconscious processing, no rack of trays, and no thousand white plastic chairs; nothing to soften the collision between a sound and what that sound means.

after sfx

Aluminum Stepladder
Army Boots
Bag of Sand
Bag of Soil
Bananas
Blackberry Curve (2011)
Brogues
Cannelloni Pasta
Car Door Instrument
Car Tire
Cauliflower
Celery
Cigarette Lighter
Cinder Block
Coins
Cornstarch
Cotton Clothing
Cricket Bat
Crocs
Cuckoo Call Whistle
Cucumbers
Curlew and Peewit Call
Dell Keyboard (2006)
Dove and Pigeon Call
Eggs
Empty Cans
Family-Size Soft Drink Bottles
Fiberglass Sledgehammer
Flip-Flops
Frog Guiros
Galvanized Dustbin
Goalkeeper Gloves
Granite Stone Tiles

Green Coconuts
Ice Cream Truck Music Box
Inflatable Pool
iPhone 5C
Iron Building Bar
Junior Punching Bag
Khubz (Arabic Bread)
Khubz (Dried/Fried)
Latex Balloons
Leather Belt with Metal Buckle
Leather Handbag
Marble Stone Tiles
Megaphone (60 Watt)
Metal Door Instrument with Foldout Scissor Slide Feature
Metal Vat
Mosquito Killer Lamp (30 Watt)
Nightingale Call
Nokia RM-908 Cell Phone
Oilcloth
Ostrich Feather Duster
Parabolic Dish
Pine Cones
Plastic Bags
Popcorn Maker
Popcorn Seeds
Porcelain Arabic Coffee Cups
Porter Bell
Potato Crisps/Chips
Quick-Release Tripod Plate Adapter
Rug
Russian Roulette Balloon Gun
Sesame Seeds
Silver Foil Helium Balloon

Slingshot
Sneakers
Steel Wool
Stilettos
Sunflower Seeds
Tissue Box
Tomatoes
Toyota Landcruiser Car Horn
Train Whistle
Tray Rack
Trays
Unwound Video Tapes
Ventilation Duct Cover
Wagon Wheel
Watermelon
Water Supply Piping (Lakhdar Brahimi)
Wicker Carpet Beater
Willow Cane
Wooden Planks
Wooden Steps (half carpeted)
Woolen Mattress
Yard Chain
Yellow Pages

Aluminum Stepladder

The metal staircase leading to the guards' room in the central atrium of Saydnaya Prison became one of the ways we could try to approximate in which area of the prison former detainees had been held. As they were led into the prison blindfolded and kept in their cell for the entirety of their detention, the witnesses I interviewed never saw this staircase, but they heard the resonant metallic *tong* of the guards ascending or descending the steps countless times throughout the course of a day. It was during my interview with Salam that it first occurred to me that I could try to use this sound as a way to locate his cell, and therefore determine from what perspective and proximity he could have heard other sounds in the prison.

In the middle of the interview I flipped open the laptop and typed "metal stairs" into a search engine for the Warner Brothers and BBC sound effects libraries. There were 245 entries. I quickly scanned the list: "FOOTSTEP, METAL STAIRS - CROSS COUNTRY SKI BOOT - LEATHER - NO SKI, RIGHT STEP, LOW RESONANT METAL STAIR." "A BODY FALLING DOWN A FLIGHT OF METAL STAIRS." "METAL STAIRS: WOMEN'S THIN HIGH HEEL SHOES: FAST STEPS." Then it jumped out at me: "FOOTSTEPS, METAL – MALE SNEAKERS: UP STAIRS." I booted up the file and played it for Salam.

Salam tilted his head, paused, and then said it was too forceful and too loud but that the essence of the metallic impact was similar. I lowered the volume and added a reverb to soften it, making it appear more distant. He seemed a little more satisfied. We both put on headphones and I asked him to imagine he was in his cell facing the

88

door. I told him I was going to move the sound from left to right and that he should signal when it got to the position he remembered it coming from. He closed his eyes. I looped the sound and slowly panned it across the stereo field. Increments before I reached the furthest right position of the pan control, he raised his left hand to stop me.

The needle of this sonic compass was pointing northwest.

Car Door Instrument

Exploding head syndrome is a hyperbolically named medical condition that does not involve anybody's head actually exploding. Rather, exploding head syndrome occurs when a short, sharp, percussive-like sound is heard just at the moment when one is about to fall asleep. The sounds described by sufferers include a pistol shot, a Christmas cracker, electricity short-circuiting, cymbals crashing, something hitting a tin roof, an electric saw, a vacuum cleaner, a stiletto striking a marble floor, and, the most common of all, a car door slamming. Some witnesses to these phantom car door sounds just leave it at that—a car door slamming—while others claim it to be the exact sound of the door of their mother's Chevrolet Blazer or a silver Ford Mustang they once owned while at college.

At the turn of the millennium, increased safety measures were introduced worldwide that required car manufacturers to add extra bars to their cars' doors to comply with regulations. This enforced a manufacturing standard that in turn meant all car doors would sound the same upon closing. As the sound of the closing door

makes an important first impression on a buyer, car companies all over the world have turned to psychoacoustic experts and sound effects artists to make their doors sound more satisfying, more secure, more expensive than their rivals'. Orchestrating the specific placement of foam, dampeners, cavities, latches, and seals ensures that each company's car doors now have a distinctive sound. The consumer, meanwhile, remains unaware that this sound is entirely crafted, that hours are poured into its design, and that it has no bearing on the build quality of the vehicle. This hidden set of acoustic effects only seems to leak out just as we are about to fall asleep.

Cricket Bat

The trial of the athlete Oscar Pistorius was dedicated to discovering if he had intended to shoot Reeva Steenkamp through the bathroom wall, or if, as Pistorius claimed, he had in fact believed that he was shooting at an armed intruder behind the bathroom door. Earwitnesses living in neighboring compounds said they heard voices shouting and arguing before hearing gunfire. Pistorius testified that after he realized it was Steenkamp he had shot by accident, he screamed in panic and grabbed a cricket bat to smash through the locked door. During the cross-examination of the earwitnesses to the crime, a replica of this bathroom door was brought into the courtroom and a forensic audio expert, armed with a cricket bat, began to beat it many times. This clamor was made to demonstrate that a cricket bat striking a wooden door could produce a deafening sound, as intense as the blast of a gunshot. The cricket-bat blast punctuated a line of questioning that sought to place a seed of doubt in the

ears of the witnesses: Had they heard Steenkamp's shouts followed by gunfire, or Pistorius's scream followed by the sound of a cricket bat striking a door? This demonstration turned the courtroom into a makeshift sound effects studio, and the expert witness into a Foley artist. Though his performance was billed as a forensic reenactment, what it actually achieved was a demonstration of the deceitful and illusory nature of sound, where clearly distinct and conventionally unassociated objects, like guns and cricket bats, become interchangeable and indistinguishable.

Dell Keyboard (2006)

On April 6, 2006, in an internet café in Kassel, Germany, Halit Yozgat was shot dead by neo-Nazis armed with a suppressed CZ-83, concealed in a plastic bag. There were no eyewitnesses to the murder, however all the customers in the café heard some loud percussive sounds.

One witness said, "I heard three sounds. Three times it went *tac tac tac*, one after the other, as if somebody was knocking on the walls of the room." Another witness described a sound that was "very loud, as if something had fallen to the ground." The closest witness to the incident said, "I heard something like a balloon exploding."

Only one of the witnesses claimed that they "didn't hear any exceptional noises," and that was Andreas Temme, an intelligence agent who did not disclose his presence to the police at the time of the murder, and was only identified later by his log-in data on one of the café's computers. This sparked suspicions of possible collusion between the agent and the neo-Nazis.

The case began to resemble that of Sherlock Holmes's "curious incident of the dog in the night-time," in which

none of the earwitnesses to a horse-race robbery remembered hearing the guard dog bark, leading Holmes to investigate whether the thief was someone the dog knew.

For is it possible one could fail to hear a balloon popping ten meters away? Could Temme's own keystrokes on a 2006 model Dell keyboard really have been so loud as to drown out the sound of a gunshot? Or is Temme the dog that didn't bark?

<u>Family</u>-<u>Size</u> <u>Soft</u> <u>Drink</u> <u>Bottles</u>

"The torture room is not just the setting in which the torture occurs... It is itself literally converted into another weapon... All aspects of the basic structure—walls, ceiling, windows, doors—undergo this conversion...

Just as all aspects of the concrete structure are inevitably assimilated into the process of torture, so too the contents of the room, its furnishings, are converted into weapons: ... men and women ... describe being beaten with 'family-sized soft drink bottles' or having a hand crushed with a chair, of having their heads 'repeatedly banged on the edges of a refrigerator door' or 'repeatedly pounded against the edges of a filing cabinet.' The room, both in its structure and its content, is converted into a weapon, [then] deconverted, undone.... Made to demonstrate that everything is a weapon, the objects themselves, and with them the fact of civilization, are annihilated: there is no wall, no window, no door, no bathtub, no refrigerator, no chair, no bed."
—Elaine Scarry, *The Body in Pain*

Green Coconuts

The sound effects in wildlife documentaries are extremely over the top. The loud slurp of a polar bear licking its paw has always removed me from the Arctic Circle and brought me to imagine some human in a dim, echoless basement recording studio, surrounded by peculiar objects which they endlessly flick, flail, brush, strike, and squeeze into microphones. Paradoxically, I rarely ever wonder about the labor of the sound effects artist in works of pure fiction like *Game of Thrones*. I only learnt quite lately that, in this show, they use green coconuts, rather than watermelons, to create the sounds of all of their decapitations. As many of us have never heard a real decapitation, I suspect green coconuts sound more like human heads to us than human heads actually do, meaning that if we were to hear a human head instead of a green coconut, we may not be so convinced. Whereas we know that the scaly skin of an iguana squirming up a rock would not sound like it was wearing a pair of leather sweatpants.

There was, however, one scene in *Game of Thrones* in which the sound effects did shatter my suspension of disbelief: it was not the rattling growl of a dragon or the stomps of a giant ice zombie which brought me hurtling back down to earth, but rather the very simple gesture of one character closing a door. As I heard this door shut, I had an acoustic flashback: I had heard that exact sound somewhere before. It was in fact the same stock "door closing" track I had played to Jamal from the Warner Brothers sound library during the investigation into Saydnaya Prison some three months earlier. This was enough to completely uncouple the sound from the images in the TV show and transport me back to that moment in the interview.

Lawrence: Jamal. Is this the sound of the door?
[*Plays door sound.*]

Jamal: No, it has a more metallic sound. Maybe if we
watch a film where a prison door gets closed, you'd
get which sound I'm talking about.

Lawrence: What about this one? [*Plays door sound option 2,
the one later heard in* Game of Thrones.]

Jamal: It's close, but not quite right. I know where we can
find the exact sound. After I got released from Saydnaya,
I became a refugee in Turkey and was looking for an
apartment in Istanbul. I visited an apartment located on
the top floor of a building, and the apartment had a metal
door so that burglars wouldn't break in. That metal door
made the exact same sound as the one I was telling you
about from Saydnaya. As soon as the door opened, I
instantly told the guy, "I cannot live in this apartment."
It made the exact same sound—if we had time today,
I would take you there so you could hear the cell doors
of Saydnaya. *Tshk, takk.*

Ice Cream Truck Music Box
On January 17, 2005, Fabian Bengtsson, a Swedish elec-
tronics executive, was kidnapped and kept in a narrow
wooden case for seventeen days before he was released.

Bengtsson never saw his kidnappers or the place he
was held, but the sound of the assailants' voices leaked
through the walls of the wooden box, along with other
acoustic signifiers. Most importantly for the subsequent
police investigation, Bengtsson had memorized what time

the jingling song of an ice cream truck passed by on the street outside every morning. This information was key in enabling investigators to find the apartment where he had been held, and so to locate and convict the kidnappers.

The story, which was widely circulated at the time by Swedish news agencies, caught the ears of Anders Eriksson, a forensic phonetician at the University of Gothenburg, and his student Lisa Öhman. They realized that although countless experimental studies had been conducted into the veracity of eyewitness testimony, there was very little research in relation to the memories of earwitnesses. This motivated them to conduct a major study into the reliability of auditory memories. They tested a total of 949 people on their ability to blindly identify human voices.

Their decision to focus only on human voice recognition means that, to this day, there still has been no major study of earwitness memories of non-voice-based acoustic stimuli.

Khubz (Arabic Bread)

In "A King Listens", Italo Calvino writes, "The palace is a clock: its ciphered sounds follow the course of the sun; invisible arrows point to the change of the guard on the ramparts with a scuffle of hobnailed boots, a slamming of rifle-butts, answered by the crunch of gravel under the tanks kept ready on the forecourt. If the sounds are repeated in the customary order, at the proper intervals, you can be reassured, your reign is in no danger: for the moment, for this hour, for this day still."

The same can be said of the prison: the sequence of sounds leaking into the detainees' cells at "the proper intervals" makes clear that the prison is in full operation

and under the tight grip of the incarcerators. But this sequence of sounds can also be used by prisoners, reverse engineering this communication of power into a score that reveals the small cracks in control, the chinks in the prison's armor, opportunities for escape that require perfect timing. During our investigation of Saydnaya Prison, we too tried to use the rhythm of the prison as a clock: slamming doors, specific commands, the creeping footsteps of the guards, the sound of torture, the arrival of specific kinds of trucks or cars, the sounds of preparation of food all timed against the distant sound of the call to prayer in *talfeta* six kilometers to the north five times a day. From this sonic clock we could draw information about the comings and goings of the guards, understand the frequency of admission of new detainees into the prison, get a sense of how long the new detainees would be held in the solitary cells in the lower ground floors before being brought up to the main wings, and corroborate across the witnesses the frequency of torture operations. Establishing the composition of sounds that made up a day in the life of Saydnaya would help us more precisely define the scale of the abuses and crimes that were taking place inside.

For example, through the orchestration of doors, footsteps, and strikes, Samer and I identified the exact journey though the prison new detainees would be subjected to. Samer spoke with clarity and precision, but when we began to place the sound of the door to Samer's wing in Saydnaya amongst this composition, none of the door sounds I played satisfied his acoustic memory, and he kept telling me to raise the volume. The sounds were getting louder and louder, until finally I played him the sound of a huge metal door slamming, with the reverb set

to "Notre-Dame Cathedral"—that is to say, that of a vast cavernous space with a thirty-five-meter-high ceiling, as opposed to the four-meter-high ceiling of the actual space in question. Upon hearing this, Samer was taken aback; he stopped me and said: "This sound was present in Saydnaya; this was the exact sound, not of the door, but of the sound of sheets of bread being dropped to the ground outside my cell. From the weight of the sound I could tell if it was five, eight, ten, or twenty sheets."

Sometime after the interview, I conducted a test, dropping packs of Arabic bread to the ground, which confirmed for me that which is written into the laws of physics, which is that even twenty sheets of bread landing on the ground could not make such a vast sound.

However, it was not the laws of physics that were at work here. Samer's complete conviction that this was the exact sound of food arriving made me understand that we were not measuring the intensity of sound, but, inadvertently, the intensity of hunger.

<u>Khubz</u> (<u>Dried/Fried</u>)
Lawrence: Which sounds from the prison do you remember hearing the most?

Anas: I remember most the constant sound of diggers digging. It stuck with me, because I don't know exactly what they were digging. Graves?

Lawrence: Diggers? Like a JCB digger truck? Digging into the ground?

Anas: Yes. It's the sound I remember most. All you hear is diggers digging. You feel like they're working on something, but you're unable to figure out what it is.

Lawrence: What did it sound like, exactly?

Anas: Like people were breaking dried-out bread. Although we never had any bread to eat anyway. We were starved.

Lawrence: So it sounded like someone was constantly breaking dried bread?

Anas: Yeah, that's what I remember hearing all the time.

Metal Door Instrument with Foldout Scissor Slide Feature
In *The Body in Pain*, Elaine Scarry writes, "Basques tortured by the Spanish describe 'el cerrojo,' the rapid and repeated bolting and unbolting of the door in order to keep them at all times in immediate anticipation of further torture, as one of the most terrifying and damaging acts." Aleksandr Solzhenitsyn's account of the Soviet Gulag, she continues, "describes how in Russia guards were trained to slam the door in as jarring a way possible or to close it in equally unnerving silence."

The doors in Saydnaya Prison had a similar effect on its survivors. Diab explained to me that "the sound is impossible to erase from one's memory." However, the sound of the doors was not only used to spread fear. Salam and others used it like sonar, an echolocation device that helped him and his fellow detainees locate the position of the guards. A technique that ultimately

allowed Salam to survive, because in every encounter with the guards one had to kneel facing the wall with your arms behind your head; if caught out of this position, prisoners would be tortured. Salam's comprehensive account of the sound of the cell doors also allowed us to approximate how many cells were in use in his wing, and was a key detail that made it possible for Amnesty International to estimate how many prisoners were being held in Saydnaya.

Salam: Every cell door—and there were ten cells in our wing—had a unique sound, and what we would do is memorize those sounds to know which cell door was being opened. I memorized them in sequence first—so, for example, the guards would open the first cell door, and we'd say, "That is the sound of door number one." Then we'd memorize the way the next door sounded different to the first door, and so on and so on. After some time we would know the distinct sound of each door, so if the guards would open a door randomly, we'd know, for example, it is door number three, because of a particular squeak of the hinges or the *tak* sound it would release from the lock. Some doors make harsh sounds, others make softer sounds, some have specifically rusted locks, you know? Each door had its own characteristic. The guards would try to use the door sounds to make you think there is more than one of them patrolling the corridor. He did not want to give us the impression that he is alone, and so, as each door had three different locks, he would open two locks at once to make it seem like two different cells are being opened by two different guards simultaneously. He would always think that he would succeed in deceiving us, but we were on to them.

Oilcloth
"Suddenly small black planes popped up from somewhere. They circled around our red army planes, and something was rattling and booming. The strange noise reached the ground ... as if someone was tearing oilcloth or linen fabric ... so loud! I didn't know yet this was the machine-gun fire heard from a distance or from high up."
—Zhenia Selenia, five years old in 1941. Now a journalist.[1]

Popcorn Maker
At 21:30 on August 13, 2013, a guest at a Florida resort was falling asleep after a long day at Walt Disney World. As she was drifting off, she was disturbed by what "sounded like popcorn." These sounds were the early warning that, an hour later, the resort would collapse into a one-hundred-foot-wide sinkhole.

If you hear the sound of popcorn unaccompanied by its distinct aroma, immediately evacuate.

Quick-Release Tripod Plate Adapter
In 2019, Arte, the Franco-German TV channel, was conducting an interview with me, a section of which was dedicated to the Earwitness Inventory, my personal sound effects library. I built this library because whenever I speak to witnesses about the sounds they have heard, we lack a language—there is no common vocabulary to describe sounds with the accuracy and precision needed for legal and advocacy work. I had experimented with using Warner Brothers and BBC sound effects libraries, and though this helped us get closer to the sounds in question, they often felt overly theatrical. So I began to

100

establish my own collection of sounds and objects that was specifically tailored to investigate earwitness accounts of corporate, state, colonial, and environmental violence.

Today, this inventory comprises a catalogue of nearly one hundred objects and many more recordings derived from the ways in which witnesses have described the sounds they have heard. Some are sourced from earwitness interviews I have personally conducted; others are scoured from books and trial transcripts. The interview with Arte was recorded in the storage unit in Beirut where I keep these objects. Shortly after I demonstrated the ways in which an ostrich feather duster could reproduce the sound of a bird taking flight, which had been an important detail in a previous investigation, we concluded the interview. While the crew were packing away their gear, I heard a voice say, "I have a gift for you." I looked up; it was the cameraman, Firas Zaineddine, brandishing a heavily worn metal object, intricate yet utilitarian. Firas explained to me that he had once filmed an interview with the former president of Lebanon, Émile Lahoud, and at its conclusion, when he wanted to remove the camera from the tripod, he pulled back and released the mechanism on this plate that allows you to detach the camera, and at that moment he was hurled to the ground and fully restrained by one bodyguard while the other vigorously searched his body, repeatedly screaming, "Where is the gun?" Firas quickly realized that the particular mechanical noise of the tripod plate had emulated the sound of a pistol being cocked back. He explained this and said that he would show them what he was talking about. Still suspicious, they lifted him from the ground and held one hand behind his back. With his free hand, Firas demonstrated for them the sound of the lever and the quick-release

mechanism. He did this a couple of times before the bodyguard released his other arm. The presidential guard, in a tone accounting for his now-evident overreaction, explained to Firas that this mechanism sounds exactly like the mechanical noise a pistol makes, and that he should be careful. "So, if you ever need to reproduce the mechanical sound of a pistol," Firas said, "you can use this." My thanks to Firas for the quick-release tripod plate, the newest addition to the Earwitness Inventory.

Sesame Seeds

Absences and ellipses in testimony can be just as meaningful as the things which are present. During the interview process with survivors of Saydnaya, I, too, devoted much of my time to trying to hear the absence of sound.

I was looking for different ways to measure the state of enforced silence because I believed that the silence itself constituted a human rights violation. The order of complete silence is used at Saydnaya to restrict prisoners' physical movements and to suppress their respiratory functions, forcing them to remain still, not cough or clear their throats, not stretch or exercise their muscles for fear of making any sound at all. If you were caught speaking or making any sound audible to the guards, you would be beaten. Thousands who could not adhere to this brutal regime of silence did not survive.

Attempting to explain to me the silence at Saydnaya, Jamal said, "One of the loudest sounds was the killing of lice," the amplitude of which, he said, was equivalent to that of "crushing a sesame seed between your thumb and forefinger."

Train Whistle

In confirming the location of a CIA black site in central Bucharest, the earwitness testimony of a former detainee was vital, due to the fact that he had heard the constant and omnidirectional sound of rail traffic bleeding through the walls.

In Bucharest there is a V-shaped conglomerate of network rail interchanges. At the nadir of this V shape stood a warehouse—the perfect place for covert operations, as even though it was in the middle of Bucharest, it was completely isolated from the city by the surrounding layers of railway infrastructure.

The release in December 2014 of a US Senate report acknowledging the existence of CIA black sites confirmed what investigators had suspected: this exact warehouse was being used as a secret prison, as part of the US rendition and torture program.

Tray Rack

"It was about eighteen minutes after midnight. A few of us strolled over to the swinging doors that gave on to the pantry. They had no glass peepholes but we'd soon hear the pleasant bustle of him coming through, as the waiters and the colored chef in his high hat and a busboy or two waited to see him. There was suddenly a banging repetition of a sound that I don't know how to describe: not at all like shots—like somebody dropping a rack of trays."
—An excerpt from Alistair Cooke's account of the shooting of Bobby Kennedy

Woolen Mattress

Many of the weapons used to beat the detainees of Saydnaya were never seen by victims, only heard and felt. When they heard others being beaten, they would listen to the sound and try to derive from it what kind of instruments were being used.

During the interviews, the witnesses and I would try to describe and think of ways to re-create these sounds, with the hope of making a comprehensive account of all the different weapons being used there. Jamal compared one weapon's sound to the strike of an iron bar landing on the top of a wooden table, and another made a sound like a leather belt against a plaster wall. Samer's descriptions involved striking a specifically woolen, not foam, mattress, while also explaining that when the guards hit the bottom of the detainees' feet, it made a sound like hitting plastic bags filled with cotton clothing.

At times, the former detainees' instructions required the combination of two, usually unassociated, objects, like when Diab said that I should hit a "leather handbag with a willow stick." Other descriptions were drawn from more familiar memories, like when Anas described a specific weapon as making the same sound as when people beat the dust out of their rugs, out on their balconies in Damascus, using wicker carpet beaters.

These objects were the materials that they thought were best suited to mimic the sounds of the real weapons, with the implicit understanding that if we had the actual weapons themselves, we could get a more precise reproduction. However, when Jamal and Salam came to describe the sound of the water supply pipe hitting someone in Saydnaya, they explained that getting the exact same weapon, and re-creating its strike, would be inadequate to achieve the sound they remembered it making.

"It doesn't sound like something is hitting a body," Jamal explains. "It sounds like someone is demolishing a wall." Salam corroborates, "Don't just get a plastic pipe and hit someone—you have to get a sledgehammer and smash it against a wall. Then you will get the exact sound we heard when they used that weapon."

Yellow Pages

In the process of accumulating my own sound effects library, specific to the investigation of earwitness testimony, I have come across many descriptions in which earwitnesses explain the sounds they heard in the negative: "It didn't sound like a punch," or "Not at all like gunshots," or "It doesn't sound like something is hitting a body."

These witnesses know what it was that they heard. They do not say, "I did not hear a punch," but that the punch they heard "didn't sound like a punch," meaning the sound that they expect it to make, which is often conditioned by sounds they've heard on TV or at the cinema.

Currently, one of the most popular punch sound effects for the screen is created by dropping a phone book to the ground. For many of us whose primary experience of violence is cinematic, this particular sound has become what we imagine and expect a real punch to sound like. Yet witnesses to actual assaults suggest that punches sound quite different. "It didn't sound like a punch, but a lighter being thrown to the ground and popping," said a witness in an Oregon courthouse, while another witness to the same punch said it sounded like "the noise of a cinder block falling on concrete." A New Zealand witness said

of a blow he overheard that it "sounded like an egg cracking," and a witness in Hastings, England, described the sound of an assault as like a "watermelon smashing." These are but a few examples I have encountered where witnesses first negate the sound we expect to hear, only to then describe the real sound in terms of alternate, imaginary sound effects of their own devising.

Our acoustic experience and memories of violence are completely convolved with the production of sound effects, to the extent that watermelons, eggs, cinder blocks, leather handbags, a rack of trays, and a cigarette lighter are not simply objects that describe an event, they are themselves devices by which memories are encoded, stored, recalled, and retrieved.

1. Svetlana Alexievich, *Last Witnesses: Unchildlike Stories* (London: Penguin Classics, 2019), 31.

the 45th parallel

Act 1: Straight Out of *GQ*

While it lasted, it was a successful three-person operation.
The two Americans buy hundreds of pistols from licensed
dealers across the state of Florida. Then they load up a
Nissan Murano and begin the long journey from the south-
ernmost tip all the way up here, to the northern border
town of Derby Line. Of all points across this nine-
thousand-kilometer border, this was the best place to get
the guns to their Canadian counterpart. Because in
Derby Line is the Haskell Free Library—and the Haskell
Free Library is a four-hundred-square-meter anomaly: a
granite-and-brick loophole in the longest land border in
the world.

This building can be entered from both Canada and the
US through the very same door. There are no passport
checks to enter the library, but there is a US border guard
sitting in that car there. The engine stays running, and
his eyes remain laser-focused on the main door. Each
visitor who crosses the street over from the US must also
exit back into the US. Those who come from the right,
from Canada, must not, under any circumstances, even
if they have a valid visa, exit the library into the US.

The border cannot be crossed here, and yet inside it's like
the border doesn't even exist. Technically, Agatha Christie
sits on a shelf on US soil, while Iggy Pop's biography is in
Canada, but visitors to the library can freely drift between
fiction and nonfiction. The bathrooms are in the US, but
anyone inside can cross this line to use them. And use
them is exactly what our gun smugglers did. They parked
the car in the United States and walked into the library.

One of them began browsing the books, while the other marched into the bathroom and placed a duffel bag of pistols in the third cubicle to the left. Guns deposited, they beelined back to Florida. The only person who seemed to notice their quick use of the library was Alex Vlachos, the Canadian. Vlachos waited until they had exited to move into the bathroom, retrieve the duffel bag, and walk out, just as he came, into Canada. Not one of them left their home country, and yet the pistols crossed the border. The Haskell Free Library became their giant illusionist's cabinet.

It's like that scene where Michael Corleone enters the restaurant unarmed, only to walk into the bathroom, retrieve a pistol, and come out blasting. In fact, the more money he made, the more Vlachos saw himself as a kind of Corleone. Until one day a librarian saw him that way too. She told the police: "This guy came in and he looked like he'd stepped right out of *GQ*. Everybody else is trudging around in Sorels and parkas, and he's in this beautifully tailored suit and expensive leather boots." Busted by the beautiful boots. Our Quebecois Corleone had forgotten that this was just a run-of-the-mill community library and... opera house.

Act 2: The Concrete Culvert

We don't know exactly what game the four teenagers from Juarez were playing that evening. But it seemed to involve a race of sorts: running up one ramp to touch the US border fence, then descending back down to the riverbed, only to speed up the second ramp into Mexico. They

raced up and down and up and down and up... until US border agent Jesus Mesa arrived.

Spotting the agent in pursuit of the boys, an onlooker took out their phone and began filming. In the video, we clearly see the moment when the boys become aware of the agent by their sudden and omnidirectional dispersal. The two boys already on the Mexican side quickly dart behind that column under the bridge. But the two closer to the US border fence find themselves in a more desperate predicament. One of the boys makes a maneuver to get away from the agent and flee to safety. But the other had no such chance. Mesa drew his pistol. He aimed it directly at the teenager's head, who froze and dropped to his knees. Mesa then grabbed the boy by the collar and dragged him to the invisible border line. Though the agent stayed on the US side, his eyes remained laser-focused on the boys that evaded him, just thirty-six feet into Mexico. One of the boys, Sergio Adrian Hernandez, would peek out from behind that column there. Each time he would steal a look, he would lean out a little more. But each time he peered out he would enter the crosshairs of Agent Mesa, who never put his pistol away. Drawn in by this ducking and darting, the person taking the video pans her camera towards Hernandez, and as she does the sun catches the camera's lens, forcing it to recalibrate the exposure. The video goes dark and three loud gunshots ring through the air. Agent Mesa murdered an unarmed fifteen-year-old boy.

Act 3: Line Drawing

When the murder took place, the murderer and the murdered were actually in entirely different jurisdictions. Though Mesa's firearm was stretched out into Mexican territory, his feet were three inches behind the American border. If Agent Mesa had stepped over the line, there would be no question of Mexico demanding his extradition for murdering their citizen. Likewise, if Hernandez had been killed here, in the US, he would be under the protection of the US Constitution. But Hernandez died there, in Mexico, and his killer was here, in America. It was up to the courts to decide whether the bullet that killed him brought along US constitutional rights, or whether Hernandez's rights, unlike the bullet, stopped at the border.

At the Supreme Court a hypothetical emerged. If Mesa could be prosecuted, could anyone killed abroad by a US agent seek justice in an American court? No, said some of judges, claiming that this only applied when the feet of the agent in question were on US soil. Such a precedent could only find application for US border agents firing guns across the Mexican or Canadian border. Anything else, Judge Kagan chuckled, would have to be "a very far-reaching bullet."

Act 4: A Very Far-Reaching Bullet

On the 29th of August 2021, an American drone operator with his feet firmly planted on US soil zoomed his camera on a group of people loading up a car with water in Kabul.

Assuming the barrels of liquid were explosives, he pulled the trigger, killing three adults and seven children.

On the 23rd of September 2018, a drone operator piloting from the Creech Air Force Base, Nevada, misidentified a residential house in Afghanistan for a Taliban prison, killing one adult and eleven children.

On the 12th of December 2013, a drone operated via satellite link from an undisclosed location in the US desert launched four Hellfire missiles onto a convoy of eleven vehicles in Yemen. The convoy was a wedding procession.

On Valentine's Day 2009, a drone piloted from an air-conditioned container one hour outside of Las Vegas was in pursuit of Baitullah Mehsud in Makeen, Pakistan. The drone launched two missiles but missed its target, and thirty civilians lost their lives. This was not the first attempt on Mehsud's life. It would take six more attempts and 194 fatalities before Mehsud was eventually killed.

Some of the judges started to do the math. Mesa's single bullet, which crossed the US-Mexico border, began to implicate missiles fired in Yemen, Syria, Afghanistan, Pakistan, Iraq, Somalia, and Libya. If this killing could be tried in the US, so too could 91,340 drone strikes. If the judges were to find Mesa guilty of this one killing, then what about the 48,308 murdered by Hellfire?

Act 5: Back to the Books

Once this hypothetical took hold of Neil Gorsuch and
Brett Kavanaugh, the two Trump appointees could think
of nothing but this mountain of souls knocking at the
US border. They deftly steered the court to a 5–4 decision.
Just one vote stood between justice for Sergio Adrian
Hernandez and the thousands like him killed across
the border.

In a parallel world, one in which Donald Trump never gets
elected, the Supreme Court votes in favor of Hernandez,
and in doing so, the US border is irreversibly punctured.
But in *this* world, this library is one of the last little cracks
in the border. When Trump enforced his Muslim ban,
this became the place where families divided by Executive
Order 13769 could gather. Those living here couldn't go
home, or they wouldn't be let back into the US—while
their friends and relatives from Yemen, Syria, Iran, Sudan,
Iraq, Somalia, and Libya couldn't get in to see them. But
as long as those banned from the US could get a Canadian
visa, they could all make their way to the Haskell Free
Library. When they would meet, they would usually eat
—and that's why these signs everywhere say, "No burgers
and extra-large Cokes." However, there's not a single sign
that says "No talking." Because for this, the Haskell Free
Library and Opera House made an exception. As one of
the librarians put it, "We are a library, but I don't want
to shush you when you haven't seen your grandmother
in forever."

contra diction [speech against itself]

When programmers were first programming computers to recognize speech for speech-to-text applications, the biggest challenge they faced was getting the computer to understand that each different voice it heard was speaking the same language. The computer heard each person as if they were speaking their own unique language. All the physical properties of speech unique to each speaking body—the size of the palate, the depth of the larynx, and lung capacity, in addition to regional accent—produce so much excess information that the computer could not understand how two people speaking the same word resembled each other in any way. And this computer, hearing each one of us speaking in a totally different language, makes us aware of the way we are also programmed to listen: we see how much of the voice of the other person we discard in favor of semantic content, how adept and focused we are on the system of language, and not on the speaker as a language in and of itself.

Over the last five years, however, computers are starting to hear more and more like we do, and by example, today's "live audio essay" is a first in the history of voice technologies. For those listening in German, I am premiering a new automatic translation software. This works by translating my live speech into English text and then translating that text into German text, and then it gives voice to that German script live into your ears, seamlessly and almost simultaneously. This automatic translation system I am premiering today is software designed by an Israeli company called PerSay Ltd., and the name of the software is FreeSpeech 4.0.

In an unlikely and ironic turn of events, FreeSpeech 4.0 was made possible because of the whistleblower Edward Snowden. When he released the secret PowerPoint presentations of the US National Security Agency (NSA), he inadvertently released the missing part of a code that PerSay Ltd. programmers desperately needed to complete their translation algorithm.

The NSA were using a top-secret highly developed speech-to-text transcription that Snowden leaked. They were so reliant on this software because even with the huge data centers they command, not even the NSA had enough data storage capacity to be able to store all the world's phone calls, Skypes, Facebook, FaceTime, and WhatsApp audio files. Text is so much less data-hungry than audio, and is so much easier to search through later. However, it couldn't be that they were using the same speech-to-text functions that were currently available, otherwise they would be storing a lot of nonsense.

So these highly accurate NSA speech-to-text algorithms are now, thanks to PerSay Ltd. and Edward Snowden, being applied to my voice as it is being automatically translated into German. But the real genius of this translation system is not the accuracy of its transcription, but the way my German voice retains the expressions, emphases, and emotions of my original speaking voice. It does this by measuring the tension of my vocal cords and determining from them my mental state, and therefore the intention behind the nonverbal vocal emphasis that I bring to the words I speak. Again, PerSay Ltd. didn't invent this technique of emotional-stress voice recognition; they also stole it. This time it wasn't stolen from

the NSA, but through industrial espionage they conducted against a fellow Israeli company called Nemesysco. You see, Nemesysco developed something to measure emotional response via the vocal cords called Layered Voice Analysis 6.50.

The application of LVA 6.50 is not for achieving an accurate vocal translation, but rather for use as a lie detector.

< Play "Anthrax Suspect on LVA 6.50" video >

The premise of LVA 6.50 is that, through a frequency analysis, the physiological conditions of stress are made audible by the nonverbal elements of a voice. This technology is said to be able to determine all sorts of psychological verdicts based on jittering frequencies, glottal tension, and vocal intensity, all regardless of the language you are speaking. It is currently employed as a lie detection method by the Los Angeles Police Department, Russian and Israeli governments, and insurance companies all over the world. The United Kingdom is using it to measure the veracity of benefit claims made by disabled citizens over the telephone. The main retailer of the software told me in an interview that based on the micro-fluctuations of the vocal cords, LVA 6.50 can not only determine whether a person is lying, but is also able to deliver a whole series of verdicts—detecting, for example, embarrassment, overemphasis, inaccuracy, voice manipulation, anxiety, and whether or not the interviewee is attempting to outsmart his or her interlocutor; in the future, I was told, it will even be able to profile someone's voice to find out if they are a sex offender.

119

< End video (when I clear my throat) >

< Turn on voice effect >

LVA 6.50 is a lie detector that situates the "truth" not in what you say, but in how you sound, in the object quality of your voice and not the words you speak. In this way the voice becomes divided into the words we say and the way we say them. This division of the voice produces two different testimonies from one person's speech—one testimony on behalf of language, and the other testimony on behalf of the body. Often these two testimonies are corroborated by each other, but they can also betray one another. An internal betrayal between language and body, between subject and object, between fact and fiction, exists in a single human utterance.

< Turn off voice effect >

So what does it mean to speak the truth in the era of FreeSpeech 4.0?

In the face of this new regime of listening, we still seem to cling to the increasingly outmoded rights and laws that govern our speech in society. For example, the human right to the freedom of speech may still be protecting what we say and the expression of our opinions, but not the expression of the voice itself. If the freedom of speech is to stand up to this new political context that our voice faces, it needs to be expanded to include and protect the sonic quality of our voices as well. Another of these laws, the right to silence, offers a mode of withdrawal from public speech, from the necessity to confess, yet it is the

very withholding of our voices that can mute our political agency. The withholding of our voices also alleges guilt by virtue of its very withholding, as we see from those in government who espouse the defense of the NSA and LVA 6.50, as they consistently proclaim that the only people who fear these systems or who don't want to participate are those who have something to hide, those who are guilty of something.

I went looking for another way, to add another legal right to these more tried, tested, and exhausted laws that govern our voices and patrol our ears. Looking for a precedent and a more robust means for our voices to retain their politics in the era of the algorithmic regime of truth production, I found an old and esoteric piece of Shia Islamic jurisprudence called Taqiyya (تقیه).

تقیه is an old and obscure Islamic law. In its simplest possible articulation, تقیه is a legal dispensation whereby a believing individual can deny his faith or commit otherwise illegal acts while at risk of persecution or in a condition of statelessness.

تقیه is often understood as a divine right to lie.

Though تقیه is not lying.

But it is not not-lying, either. تقیه is a contradictory condition of being simultaneously inside and outside of the law. Like police informants—who can legally commit illegal crimes whilst under the employment of the police.

تقيه is an elusive strategy of survival that is both employed in day-to-day life and in the most perilous of situations. For one Islamic community called the Druze, تقيه is fundamental to their theological and social practice. For the Druze, prayer is typically private, and there are no mosques found in Druze communities. تقيه, then, is the concept through which the non-coercive religious activity of the Druze is maintained. Here, the belief is that making one's religious thoughts public is a form of sacrilege against the private dialogue you have with God. So تقيه is not only a legal dispensation to lie and an act of dissimulation, but a technology of withdrawal from the fundamental obligation to perform oneself in public, to speak on behalf of one's self, to confess one's heart of hearts.

The Druze are transnational, spread across the Levantine countries and concentrated in the mountain regions of Syria, Lebanon, Palestine, or Israel. Their practice of تقيه is a product of their geography: a form of communication forged at remote altitudes, at the fringes of failed states, in buffer zones and on ceasefire lines.

< Play "Conversions" video >

In late December of 2013, the al-Qaeda militia—Jabhat al-Nusra (Nusra Front)—took control of Idlib province in northern Syria. As a result, eighteen Druze villages in the region became subject to mass conversions from the Druze doctrine to Wahhabi Islam. Saudi national Sheikh Saad Said al-Ghamidi led the mission.

Al-Ghamidi's crusade to convert the Druze was extensively and proudly documented and uploaded. In the images

we see al-Ghamidi and Jabhat al-Nusra simultaneously armed with machine guns and humanitarian supplies as they entered the remote villages. Though the use of force here was always a present danger, violence was only ever enacted upon the speech of this community. It was their voices in particular that al-Ghamidi came to elicit and take into custody.

As the Druze typically do not attend mosques and do not pray in public, the first act of al-Ghamidi's conversion was to teach one member of the Druze community to become a muezzin—the person who sings the call to prayer. By teaching one of the Druze to become a muezzin, he constructs the loud audio infrastructure of Islam into villages which have only heard the hushed and private voice of religious belief before. The coercive and interpolating voice is still heard as a remnant of al-Ghamidi's mission in the region, and he intends the Azan to be billowed from the top of these mountains as a form of sonic conquest.

The second act of domination al-Ghamidi performed over the voices of this community was to sit in front of each of these villagers (man, woman, and child) and hear them say the speech act of Islamic conversion, words that once uttered aloud would officially initiate them into Islam.

< Fade out audio from video >

< Turn on voice effect >

"Ash-hadu an la ilaha ill Allah. Wa ash-hadu ann Muhammad an-rasullulallah."

123

< Fade up audio from video >

In all this video material we hear no comment from those Druze converts, and we only hear their voices as they are captured in the act of conversion or when singing the call to prayer. The silence of their resistance created a void of speech that was quickly filled by journalists and political commentators.

Some claimed this conversion was merely an act of تقيه and that these conversions didn't count as they were forced under threat of violence. Others claimed that the community willingly converted and celebrated the event as a step toward Islamic unification. In the absence of vocal resistance to the conversions, one began to hear in the voice of the Druze of Idlib whatever one wanted to hear.

One can never know whether this was an instance of تقيه or the truth, because in any act of تقيه, truth lies in the ears of its beholder. تقيه is never the expression of one clear position but a multitude of statements that all emanate simultaneously from one voice—each of its numerous truths are forged by and for the ears of its listener.

It became important for me to understand the events in Idlib—not to get to the truth of what happened there, but because locked into this event was the key to understanding the concept of truth in the age of FreeSpeech 4.0.

I went looking for answers in the Druze scriptures. The Book of Wisdom, the religious book of the Druze, is

never kept in one place. Rather, the chapters of the book are divided up and each chapter is housed in different homes so that the book is dispersed across an entire Druze village. I had immediate access to the chapter that was stored in my grandfather's house, but there was nothing relevant to تقيه inside, so I went knocking on the other houses to see if some other person in the village might have the relevant chapter. Yet with every doorbell I rang I was sent to another house in the village, and before I knew it I had arrived back at my grandfather's house without having had access to any other chapters of the book. I sat there on the curb feeling defeated and was staring into the distance at a fruit tree on the side of the road.

On this tree there was something moving in the wind and glistening in the sun. I went for a closer inspection and saw that all the trees were covered in cassette tape from old audio cassettes. This is a vernacular technique that uses the obsolete media to ward off the birds and stop them eating the fruit on the trees. I started following the trail of cassette tape, and this led me into an orchard of clementines; deep in this orchard I noticed that the cassette tape on the trees was much thinner than all the rest. On closer inspection I realized that this was a tape from a mini cassette, the type usually used in old personal Dictaphone recorders. Anticipating a kind of biographical, confessional, and personal content to this recording, I collected all the Dictaphone tape from the trees and harvested the voice that was magnetized to its surface. The voice on the cassette was mostly recoverable, and to my great joy what I found on this cassette was a scholar's personal interpretations of the Druze scriptures. At the

beginning of the tape we hear this voice identify himself as Wissam Abu Dargham, a student of the prominent theological Druze scholar Dr. Sami Makarem. There are sections of this recorded monologue that are specifically about the concept and practice of تقيه, and it is these sections that I will play for you today.

So here Wissam defines the term تقيه.

< Play Dictaphone >

WISSAM: *In our part of the world, mothers talk to their newborn babies in a language called INGHH APOO. It is a two-syllable word composed of INGHH and APOO. It means nothing; it has no meaning. It is just two sounds—INGHH and APOO—used to communicate with the newborn child. The newborn baby perhaps does not understand—it doesn't have any way of processing this information in its brain to really understand anything other than the abstract sound of the mother's voice. So what does the INGHH APOO communicate? What is flowing through these two syllables? It is love and care. So the child receives these two sounds that don't make any linguistic sense but transmit the mother's love. The language will grow with the child as the mother raises the communication skill to a higher level. When the child has grown older, the mother will say, "Let's go for breakfast." Then when the child grows older again and goes to school, the mother will say, "Take your sandwich with you." When the child becomes a student in college, there is no way the mother will say to her child INGHH APOO. So تقيه is the means of communication that you adapt to any person, based on the amount of knowledge that he or she is capable of understanding. You speak to people on the level of the other's readiness to listen.*

126

< Stop Dictaphone >

From a very early age, the Druze learn how to pronounce correctly all the Arabic phonemes, which is not done by any other group of Arab speakers, from the Gulf to the Atlantic.

The correct pronunciation that many Druze speak is made audible to most other Levantine Arabic speakers by the articulation of the Arabic letter ق, a letter most closely aligned with the English letter *Q*, but here the sound is produced at the point of the Adam's apple.

< Turn on voice effect >

The Druze have become known for pronouncing this letter, as throughout the Levant one rarely hears this letter articulated as it appears in the alphabet, but rather hears it dropped, and pronounced as "ء", replacing the "ق" sound with a glottal stop; similar to the British "t" in the word *butter*, as it is often pronounced "bu'er."

Butter – bu'er

Taقiya – Taءiya

< Turn down voice effect >

Wissam speaks about this:

< Play Dictaphone >

127

Truth means that you have to respect the words. When you respect the truth of the language, you have to pronounce it as it is. To elaborate your pronunciation properly, as the language intends, also carries a meaning within it on the level of truthfulness. We pronounce all the Arabic phonemes correctly in order to stick to the basic rules of the language itself. Because if I pronounce the letter ق (qaf) as "ء" (af), I'm not saying it correctly, so I am also not "speaking the truth."

< Stop Dictaphone >

"I'm not saying it correctly, so I am also not speaking the truth."

Both words in the Arabic language that mean "truth"—حقيقه—and "trueness"—صدق—contain the letter ق. To literally speak the truth one must pronounce the ق. If one drops the pronunciation of the ق and pronounces the word *truth* with a glottal stop—"حق" as "حى"—they are simply not speaking the truth as it truly sounds. Here the sound of the word and its meaning are in a highly sensitive relationship, as it is believed that God created the Arabic language, and its words are considered divine creation just as much as the things to which those words refer. That means that the Arabic language, under this conception, is not a representation of things in the world, but actually language is another mode for that thing to exist. The sound of the spoken word in Arabic is therefore inherently onomatopoeic, whereby the form of the thing and its sound are one and the same. In fact, *onomatopoeia* in English has come to mean words that mimic the sound of the thing to which they refer: *crow, bell, wood, drum*. But its original meaning is a composite of Greek words

that mean "making or creating names": the original forging of vocal sound to an object. A process that is at the genesis of all languages, regardless of belief in God or not.

In all of its articulations, God intended truth to be enunciated with one's Adam's apple. صدق اللسان (literally, "the trueness of the tongue") is the term used to govern not only speaking the truth, but pronouncing the words correctly.

Yet the Druze have another way of writing this word from other Muslims: صدق (literally, "sincerity" or "trueness"). Druze replace the "ص" sibilance with the other "s" sound in Arabic: "س."

So rather than pronouncing it "sincerity," they pronounce it "sencerity."

س \ ص

Sincerity becomes *sencerity*.
سدق becomes صدق.

صدق \ سدق
صدق \ سدق
صدق \ سدق
صدق \ سدق

Here the pronunciation of the truth—صدق \ سدق—remains almost completely intact. There is a small deviation in sound, almost too minute to pick up if you are not really listening for it—though the form of the

written word is completely altered. Truth—though it may sound the same to those who hear the word pronounced—literally takes a different form. By deviating in the spelling of the truth, it is claimed that there is another understanding of what it means to speak the truth; that speaking the truth is not about what you said, but in the way of saying it, in the pronunciation of the letters themselves. So you can always be pronouncing the truth, while in fact the meaning of the words you speak are not so faithful.

However, this nonverbal truth can be at times just as revealing as a verbal truth. For example, pronouncing the ق would often reveal your "true" identity as Druze (as it is mostly only the Druze who pronounce the ق). Even if you claim something to the contrary, the ق speaks for itself. It does not "speak at the readiness of the other to listen," adapting to their way of hearing—rather it asserts its difference on the ear of the interlocutor. A difference that has historically been fatal to reveal.

< Play Dictaphone >

WISSAM: *One of the main mistakes of the Druze minority is that they are not practicing Taqiyya properly. If you take the case of the Druze community worldwide today, or any other minority, one of the mistakes of those minorities is that they take on a group ego; they make a sign above their head saying, "Hey, look at us; we are a minority." In the understanding of Taqiyya, you have to blend into your surroundings; taking on a collective ego is a breach. And in any minority, if they really are practicing Taqiyya, they should not label themselves as an identifiable community. So according to Taqiyya, if I am a*

Druze living in Beirut, surrounded by non-Druze who don't pronounce the ق (qaf), I should pronounce ق as "ء" (af) [as a glottal stop]. If I'm living in the mountains [in a Druze stronghold filled only with those who pronounce the ق (qaf)], I should not pronounce it "ء" (af), unless the "ء" (af) would be accepted there—I should vocalize it "ق" (qaf). But in general, if I speak "ء" (af) or "ق" (qaf) in any community in order to get attention to my ego, under تقيه I'm doing something wrong. So it's a very fine line, because speech is really interconnected and entangled with the ego.

< Stop Dictaphone >

In linguistics the name for تقيه is "accommodation theory." Accommodation theory identifies two different types of speaker: convergers and divergers. The divergers are those stubborn individuals who maintain a form of speech that is distinct from those they are speaking with. This will to diverge is a mark of their linguistic territoriality or other vocal origin with which they strongly identify.

The convergers are those generous souls who assimilate through a constant process of dissimulation: constantly adapting, always able or willing to inflect their speech to be in greater proximity and conformity to those they are in dialogue with. The convergers are those who constant-ly deviate from their "true" linguistic origins, or perhaps are simply not bound to any linguistic origin at all. Rather than a speech that identifies itself and is in turn easily identifiable, the convergers speak in many accents and with multiple tongues. Their speech is malleable and mimetic, contagious and contaminated.

131

< Turn off vocal effect >

Yet those who practice تقیه are neither convergers nor divergers—they are a rare amalgamation of the two forms of speech: a converger/diverger. When one speaks تقیه, with each word they pronounce they are making a sound that is at once dissonant and consonant to the ears of those who hear them.

< Play video >

A woman is talking with a friend without using the qaf (ق), but when a member of her family calls her on the phone, her deep glottis suddenly springs into action. What you hear is a subconscious practice of تقیه, or code-switching, that is as deeply embedded as any other instinct of survival.

If you don't speak Arabic, you are at a distinct advantage: you are able to listen to this recording as pure vocal sound.

So تقیه is not unlike the freedom of speech—it is the right to free expression, but it is more like the freedom of the speech itself, rather than the freedom to speak. It is the freedom to use your voice to mimic and mutate, to dissimulate in order to navigate the sometimes hostile terrain of those ears that prey upon your voice. It is not the freedom to stake a claim, nor the freedom to say whatever you want, but the freedom to use speech as a tool to become anything you want.

< Play Dictaphone >

WISSAM: *Yes, in the freedom of speech I'm legally allowed to say anything, to say whatever I want, but when we think about this in relation to* تقيه, *it is more like the freedom of speech is the freedom to remain silent.* تقيه *means that I'm allowed not to speak. If silence is not part of the freedom of speech, then speech will not be free.*

< Stop Dictaphone >

تقيه is not unlike the right to silence: the legal right against self-incrimination, or pleading the Fifth Amendment as it is often referred to in the USA. تقيه is a legal dispensation to not speak the whole truth if the truth may cause you harm. Yet silence and secrecy infer guilt in today's all-speaking, all-hearing world, and تقيه's strength is that it can exist as silence in the guise of speech.

< Stop video >

تقيه does not produce the loud present absence of silence. تقيه is silence camouflaged by words. In تقيه there is no binary division between what one says and what one does not say; there is not one but many silences that fill the spectrum of speech. From INGHH APOO to the pledge of Islamic conversion, a whole range of silences can be employed.

Unlike the freedom of speech, the right to silence is not a human right, and is only granted to citizens of nations that employ this law. In conditions of statelessness or in precarious jurisdictions, and in any context where silence itself is criminalized, تقيه will continue to play out in the minutiae of human utterance. It is adapted by individuals

133

who inhabit in-between spaces, and it is in fact a legal right to inhabit such in-between spaces: the space in between truth and lie; the space in between the act of saying and what was recorded as said; the space in between resistance and capitulation, between converger and diverger.

تقيه is a simultaneously subservient and subversive form of political action.

تقيه is a contra-dictionary concoction of simultaneously speaking freely and remaining silent.

تقيه is the only legal right that recognizes the inherently unfaithful nature of the voice.

< Play Dictaphone >

WISSAM: تقيه *is the truth*.

I would like to express my huge gratitude to James Hoff for creating the opportunity for this book to come to life, for envisioning its potential, and for carefully guiding it into something I am very proud of. Equally holding the steering wheel steady has been David Bennewith; I am delighted to celebrate the third book we make together.

A huge thanks also goes to everyone who helped bring the performances, that this book is derived from, to life: Bassel Abi Chahine, Meg Abu Hamdan, Shakeeb Abu Hamdan, Tarek Abou al Fatouh, Maan Abu Taleb, Alserkal Arts Foundation (Abdelmonem AlSerkal, Vilma Jurkute, Nada Raza), Jarred Alterman, Skye Arundhati-Thomas, Tairone Bastien, Myriam Ben Salah, Zachary Cahill, Irene Calderoni, Fabio Cervi, Philippe Charpentier, Moe Choucair, Agata Cie lak, Stuart Comer, Paul DiPietro, Oliver Evans, Mahdi Fleifel, Jan Goossens, Arthur Gruson, Hannah Higgins, King David Jackson, Ana Janevski, Nesrine Khodr, Omar Kholief, Eli Keszler, Adrian Lahoud, Adam Laschinger, Robert Leckie, Matthias Lilienthal, Carl-Oskar Linne, Andrea Lissoni, May Makki, Caline Matar, W.J.T Mitchell, Luke Moody, Alex Mor, Aram Moshayedi, Rabia Mroue, Robert Müller, Aamna Muzaffar, Dala Nasser, Nancy Nassereldin, Selma & Sofiane Ouissi, Maureen Paley, Julia Paoli, Hoor al Qassimi, Milan Ther, Christine Tohme, Nora Razian, Theodor Ringborg, Ghalya Saadawi, Walid Sadek, Fabian Schoeneich, Micheal Schuh, Susan Schuppli, Andree Sfeir, Ana Siler, Amanda Sroka, Polly Staple, Christina Varvia, Eyal Weizman, Caroline Wilkinson, Carly Whitefield and Nabla Yahya.

– Lawrence Abu Hamdan, 2023.

Primary Information would like to thank Ruba Katrib, Lawrence Kumpf, and Justin Luke.

Live Audio Essays
© 2023 Lawrence Abu Hamdan

ISBN: 979-8-9876249-5-1

Images on pages 1 (interior, front cover), 6, 140-141, and 144 (interior, back cover) are from a performance of *Air Pressure* at the Sharjah Art Foundation, 2022. Courtesy of Lawrence Abu Hamdan and Sharjah Art Foundation.

Image on pages 2-3 is from a performance of *Contra Diction: Speech Against Itself* at Haus de Kulturen Der Welt, 2013. © 2013 Dusan Solomon.

Image on pages 4-5 is from a performance of *Air Pressure* from "This Is Not Lebanon: Festival for Visual Arts, Performance, Music, and Talks" in 2021. © 2021 Christian Schuller.

Image on page 139 is from a performance of *Natq* at the Sharjah Art Foundation, 2019. Courtesy of Lawrence Abu Hamdan and Sharjah Art Foundation.

Image on 142-143 is a film still from *Walled Unwalled*. © 2018 Lawrence Abu Hamdan.

Designer: David Bennewith, colophon.info
Editor: James Hoff
Copy Editor: Allison Dubinsky

Primary Information
232 3rd St, #A113
The Old American Can Factory
Brooklyn, NY 11215
www.primaryinformation.org

Printed by Benedict Press, Münsterschwarzach Abtei, Germany

Primary Information is a 501(c)(3) non-profit organization founded in 2006 to publish artists' books and artists' writings. The organization's programming advances the often-intertwined relationship between artists' books and arts' activism, creating a platform for historically marginalized artistic communities and practices. The organization receives generous support through grants from the Michael Asher Foundation, the Patrick and Aimee Butler Family Foundation, The Cowles Charitable Trust, Empty Gallery, The Fox Aarons Foundation, the Helen Frankenthaler Foundation, Furthermore: a program of the J. M. Kaplan Fund, the Graham Foundation for Advanced Studies in the Fine Arts, the Greenwich Collection Ltd, the John W. and Clara C. Higgins Foundation, Metabolic Studio, the New York City Department of Cultural Affairs in partnership with the City Council, the New York State Council on the Arts with the support of the Office of the Governor and the New York State Legislature, the Orbit Fund, the Stichting Egress Foundation, VIA Art Fund, The Jacques Louis Vidal Charitable Fund, The Andy Warhol Foundation for the Visual Arts, the Wilhelm Family Foundation, and individuals worldwide. Primary Information receives support from the Henry Luce Foundation, the Willem de Kooning Foundation, and Teiger Foundation through the Coalition of Small Arts NYC.

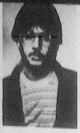

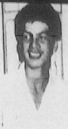

شهيد القصف الفا
١٩٨٢/٩/٢٩

شهيد احمد أرقي
١٩٨٢/٩/٢٧

شهيد القصف الهاني
١٩٨٢/٩/٢٨

شهيد شركة ، الحي القبلي
١٩٨٢/٩/٢٠

شهيد . ه وائل الجمل
١٩٨٢/٩/٩

رايد نور الدين شرفتا
١٩٨٨

الشيخ رضا شاكبب أبو ،
١٩٩٠

الشيخ شوقي أمين أبو زلف
١٩٦٥

الشيخ أكرم فوزي أبو زكي
١٩٩٠

القمرة الأجنبية
١٩٩٨

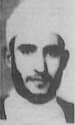

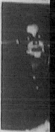

شهيد فواجب
١٩٨٤/١/٣١

شهيد حمر كا ، رأس داعر
١٩٨٨/٢/٩

شهيد قصي
١٩٨٢/١١/٢

زلاء بتروفر

حمام قواسي قنبحان
١٩٦١

عبداب ابو عامر
١٩٩٠

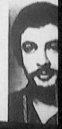